Historic England

Norfolk

Pete Goodrum

AMBERLEY

For Ottilie Eve Ingram, our granddaughter
In all our hearts forever

First published 2019

Amberley Publishing
The Hill, Stroud, Gloucestershire, GL5 4EP
www.amberley-books.com

The publisher is grateful to the staff at Historic England
who gave the time to review this book.

All contents remain the responsibility of the publisher.

ISBN 978 1 4456 9151 0 (print)
ISBN 978 1 4456 9152 7 (ebook)

British Library Cataloguing in Publication Data.
A catalogue record for this book is available from the
British Library.

Typesetting by Aura Technology and Software
Services, India. Printed in Great Britain.

Contents

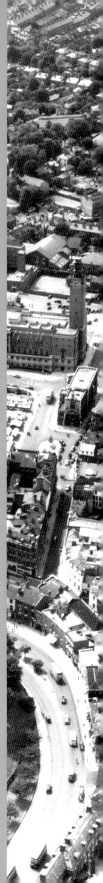

Introduction

It's often said that there's a remoteness about Norfolk. Some claim it's because you don't travel through it to get to anywhere else, which is a fair point. After all, the county's northern and eastern borders are the North Sea. Perhaps Norfolk's famous attitude of 'do different' comes from this supposed isolation.

And yet, the place has no shortage of visitors. Far from it. The Norfolk Broads are known worldwide. They, and their neighbouring rivers, are adored by sailors and holidaymakers alike. The county's coastal towns and seaside resorts are as popular as ever. Norfolk's countryside is loved by walkers, birdwatchers, cyclists and those happy to simply stroll about.

As a centre of agriculture Norfolk is essential to the nation's economy. It has been pivotal in the development of farming. North Norfolk, Holkham and 'Farmer' Coke are forever and inextricably linked to the agricultural revolution.

At its heart Norfolk has the ancient city of Norwich. Until the Industrial Revolution shifted the axis of wealth Norwich, as a city of importance, was second only to London. Today, it's the major commercial, industrial and cultural centre for East Anglia, and a sought-after place to live and work. It's still one of the most complete medieval cities in the country.

This illustrated history provides a different look at Norfolk's past. The photographs are taken from the Historic England Archive, a unique collection of over 12 million photographs, drawings, plans and documents covering England's archaeology, architecture, social and local history.

Given an 'access all areas' pass to this huge photographic archive, it became apparent to me that it contained a significant number of photographs of Norfolk, many of which have seldom or ever been published. This book is made up of my selection from those images. It's not been an easy task to decide which pictures to include. I've chosen images that show an unexpected view, haven't been published before, or capture something of the place; and, ultimately, reflect an historic aspect of Norfolk.

This book does not pretend to be a complete history of the county. Rather, it is an opportunity to show some precious photographs that, at the same time, tell something of the story of Norfolk.

Beginnings

There are signs of humans having lived in Norfolk over 800,000 years ago. Footprints found at Happisburgh are cited as being evidence of the earliest known humans in northern Europe. Dating from 5,000 years ago, Grime's Graves are genuine Neolithic flint mines and a vital part of Norfolk's history.

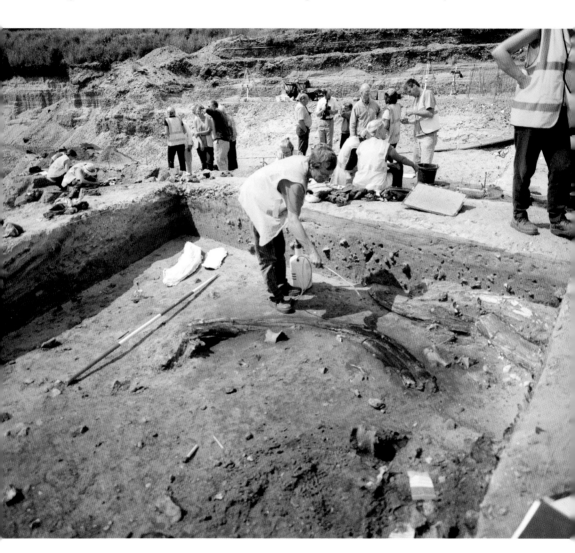

Sandpit, Lynford Road, Ickburgh
There is something remarkable about the discovery of tangible links with ancient history. Evidence of prehistoric life is precious. We know that mammoths once roamed Norfolk. Here, having unearthed some remains, archaeologists spray a tusk to prevent it drying out during the excavation. (© Historic England Archive)

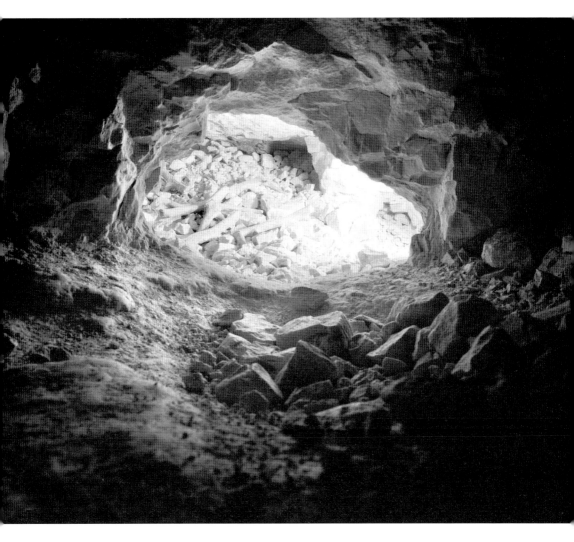

Grime's Graves
It wasn't until the 1870s that Grime's Graves was formally recognised as being the site of Neolithic flint mines. At over 5,000 years old these pits could be one of the earliest known places of work. Early man's resourcefulness and skill are dramatically demonstrated by this cache of antler picks, found lying at the end of one of the mine shafts. Research has shown that the miners were mostly right-handed and that they preferred, as picks, the left side antlers, which were naturally shed every year. The name Grime's Graves is a corruption of Grim's Graves, so-called because the Anglo-Saxon inhabitants of the area thought the site was made by the Saxon god Grim. (© Crown copyright. Historic England Archive)

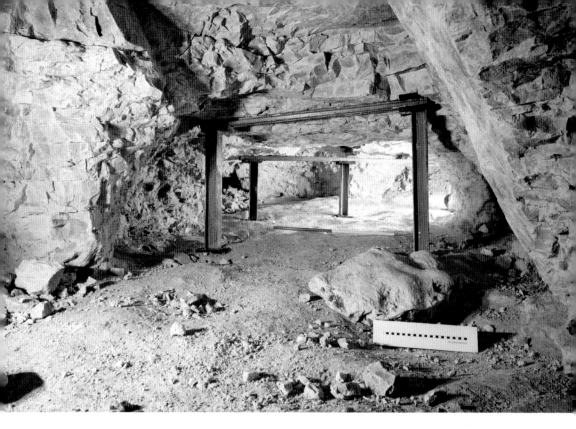

Grime's Graves
Taken in 1996 this picture shows just how sophisticated these ancient mines, and miners, were. There is evidence of them using wooden ladders to access the mine shafts. This is an interior gallery in the south-east of Grime's Graves. Thousands of years have passed but abandoned flints still lie in the foreground. (© Crown copyright. Historic England Archive)

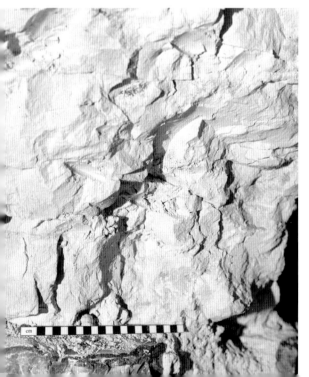

Grime's Graves
A miner makes his mark. The tool marks on a gallery wall are clearly visible in this 1996 photograph. These are the scratches made by a Stone Age worker using an antler pick in the relentless and dangerous digging for flint. There were over 400 pits dug here. Flint was shaped and sharpened – flint knapping as it's called – to make weapons and tools. Flint could also be made to spark to make fire. It would become a building material and its use would define the appearance of much of Norfolk. (© Crown copyright. Historic England Archive)

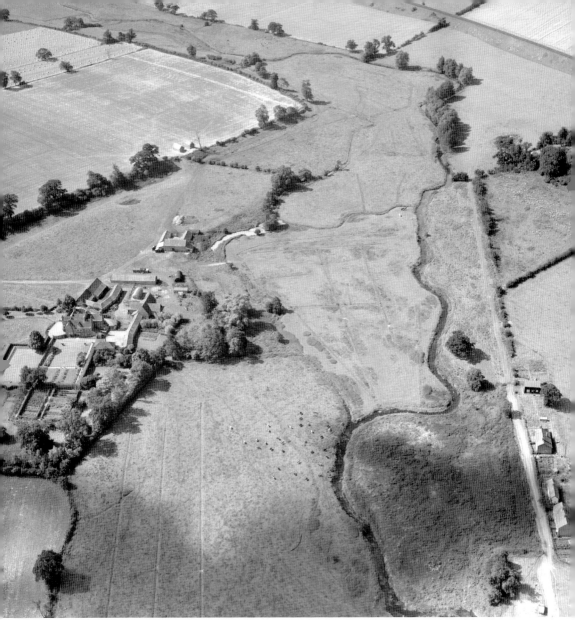

Venta Icenorum
An aerial view such as this is something the inhabitants of Venta Icenorum, the Roman town with embanked walls at the top of the picture, would never have seen. The site of the town is at what's now known as Caistor St Edmund. Venta Icenorum was the capital of the Iceni tribe. It was the Iceni who, led by Boudica in AD 61, rose up against the occupying Roman army. This photograph was taken in 1953. Just twenty-five years earlier, in 1928, another aerial photographer had been on a reconnaissance flight for a local farm. The images taken had shown evidence for the layout of the street pattern of the town and the outline of the central buildings, which led to five years of archaeological digging and subsequently the rediscovery of this important settlement. (© Historic England Archive. Aerofilms Collection)

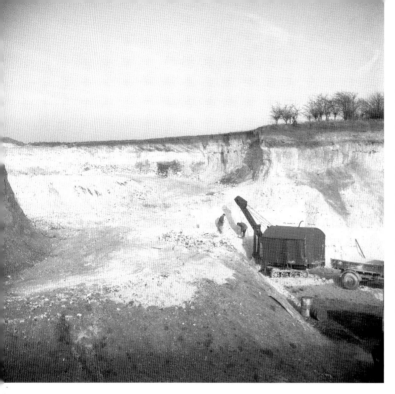

Caistor St Edmund

A 1954 photograph of the quarry at Caistor St Edmund, on the site of Venta Icenorum. Digging into the Norfolk chalk had progressed. This 1950s excavating equipment is a long way from the grim and dangerous work of mining with antler picks in Neolithic times at Grime's Graves. Flint, sand and chalk are still quarried and produced here. The chalk has particularly high levels of fossils. (Historic England Archive)

Caistor St Edmund

In this modern photograph at Caistor St Edmund there is no immediately visible trace of the settlement of Venta Icenorum; however, the remains of the town are there. So too is the site of an Anglo-Saxon burial place. A 1930s excavation revealed more than 700 burial plots and cremation urns. This view is looking west towards Dunston. (© Historic England Archive)

Churches and Mills

Two types of building that punctuate the Norfolk skyline more than any other are the county's numerous churches and mills. The spires are a reflection of the Church's former wealth and importance. The mills are links to Norfolk's agricultural heritage as well as the battle to drain the land.

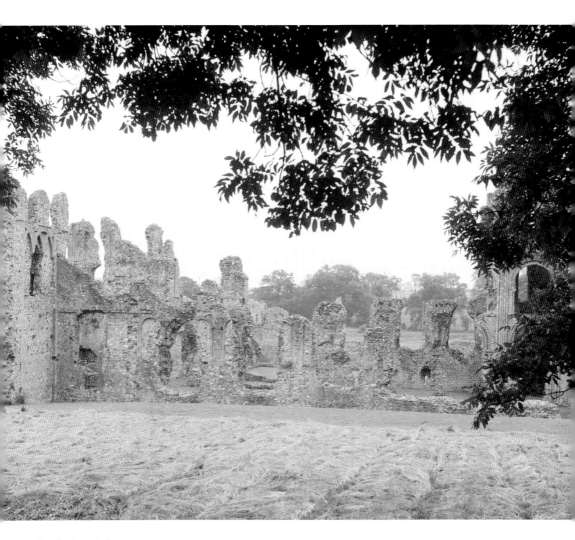

Castle Acre Priory
Castle Acre Priory is thought to have been established as early as 1089. Founded by William de Warenne, it was originally situated inside the walls of the castle, but it was moved within a year of being established. Castle Acre was a place of great political significance. Royalty often visited here and it was the location for debate on matters of national importance, but this would all change when the priory was dissolved in 1537. This 1950s photograph captures the ruins, which are now cared for by English Heritage. (© Historic England Archive)

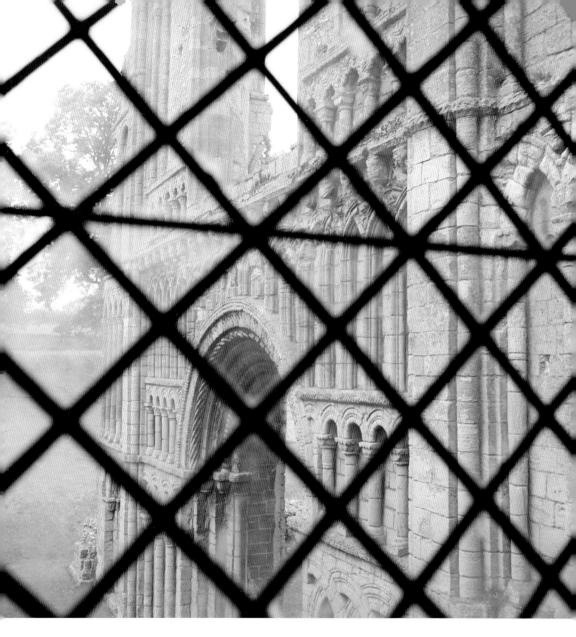

Castle Acre Priory
Taken on the same day as the general view of the priory in 1956, this atmospheric shot features the famous west front of the church at Castle Acre Priory, shown through the leaded light widow of the Prior's House. The monks at Castle Acre were ejected from the place when Henry VIII dissolved the monasteries. He gave Castle Acre, and all its estates, to the Duke of Norfolk. (© Historic England Archive)

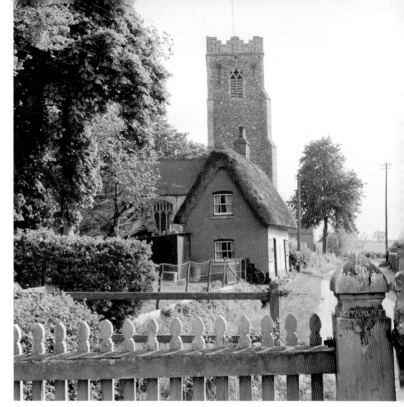

Norfolk
The precise location of this shot is not recorded. Photographed in 1956, it could, aside from the telegraph poles, have been taken decades earlier. The rural idyll of a gate, a garden and a cottage in the shadow of the church are as redolent of village life as anything can be. As is often the case, the size of the church and its tower seems to bear no relationship, other than perhaps inverse proportion, to the size of the village. (© Historic England Archive)

St Mary's Church, Denver
A mile or so from Downham Market, Denver was listed as having a population of 847 in the 2011 census. This picture was taken almost forty years earlier, in 1972. St Mary's Church, like many in Norfolk, has ancient origins. Some of it dates back to the thirteenth century. The Victorians carried out a significant refurbishment in the 1870s, meaning that the building you see now is less than wholly original, but it's an impressive square tower, still standing proud over a small Norfolk town and set in its churchyard among its gravestones. (© Historic England Archive)

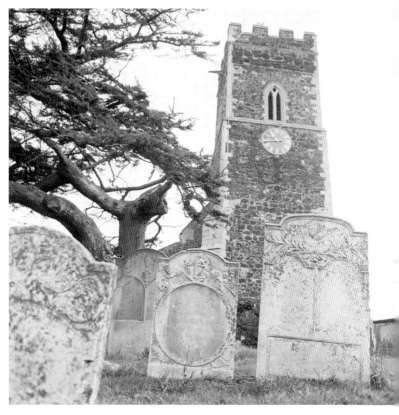

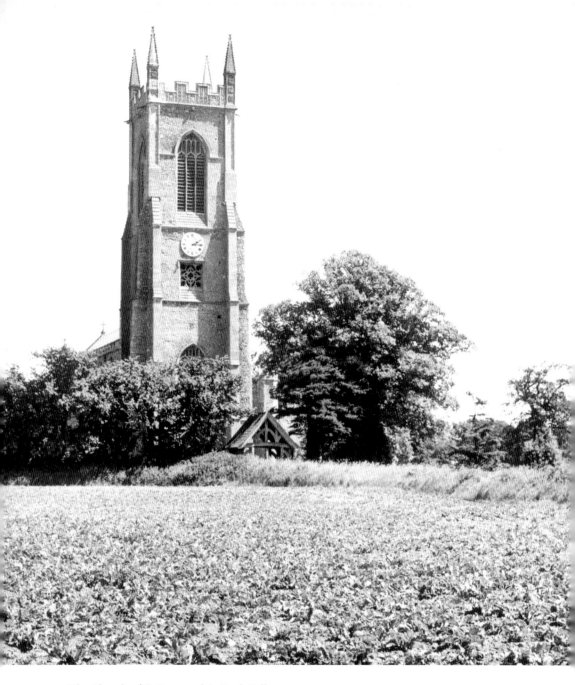

The Church of St Peter and St Paul, Salle

Sometimes a rural church seems to rise up out of the fields that sustain the community around it. This excellent example of just such a church tower is at Salle. Designed in the Perpendicular style, this huge building has its origins in the fifteenth century. Described in *Fifty English Steeples* as 'the most perfectly composed of all late medieval Norfolk towers', this 130-foot construction is faced with Barnack stone and flint. It's another ecclesiastical statement of wealth and power, although when the medieval wool industry faltered this great building fell into disrepair. It was refurbished in the early twentieth century. Today it still stands, soaring above the village, in impressive relief against the huge Norfolk skies. (Historic England Archive)

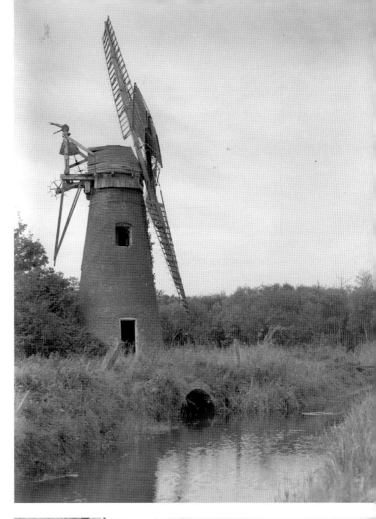

Wayford Bridge Mill
If there's another building of any type that defines the Norfolk skyline it's the mill. As civilisation emerged from the Dark Ages and people began to tame the East Anglian landscape, the wind pump became a vital part of Norfolk life. Wayford Bridge mill was already out of use when this picture was taken in 1946. It had been built almost exactly a hundred years earlier but was in financial trouble as early as the 1880s. By the 1980s the Broads authority were investigating plans to replace its cap and sails. (Historic England Archive)

Horsey Staithe
Horsey Windpump has been restored and reopened to visitors. It is the largest wind pump on the Norfolk Broads. Built in 1912, making it a comparative 'youngster' by Norfolk standards, Horsey Windpump was struck by lightning in 1943 and put out of action. It would be 2019 before a full restoration was complete. This shot, from 1961, shows men making an earlier attempt to replace the damaged sails, a project completed in the following year. (Historic England Archive)

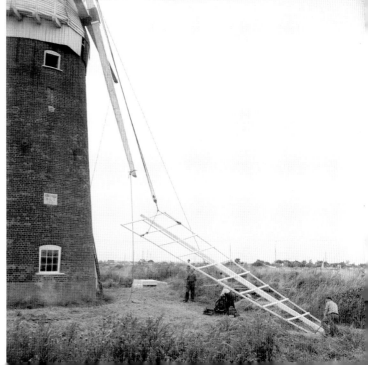

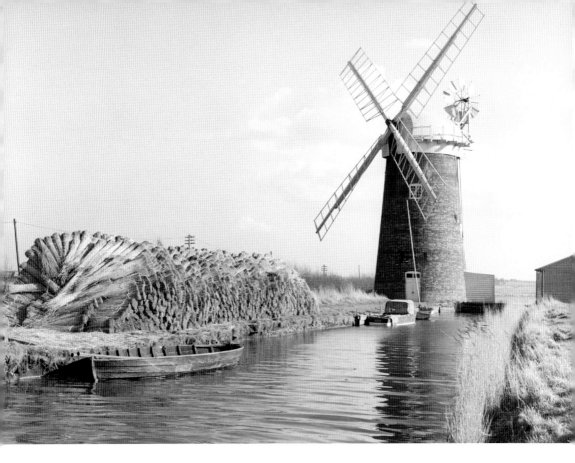

Horsey Staithe

An April 1963 shot of Horsey Windpump with the replacement sails in place. The huge stack of cut reeds is another classic piece of life in Norfolk's Broadland. They would be destined for thatching roofs. While thatching is a craft long associated with the county, in fact Norfolk does not have as many thatched roofs as some other counties, such as Dorset. Ironically, Norfolk used to import some reeds. The local pantile is actually a more typical Norfolk roofing material. (Historic England Archive)

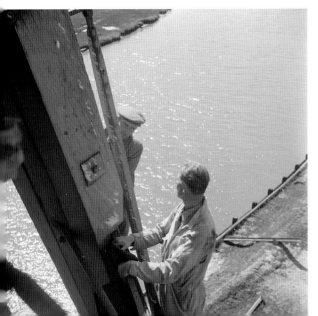

Berney Arms

A millwright is working on the sails at Berney Arms on 18 May 1948. The Berney Arms Windmill stands in an isolated spot. There is no road access. It's the tallest drainage mill in Norfolk and its cap, just like an upturned boat, makes it a defining landmark. Built in 1865, it was originally used for cement production but converted to drainage use in 1883. Closed down in 1948, it was handed over to the Ministry of Works in 1951. (Historic England Archive)

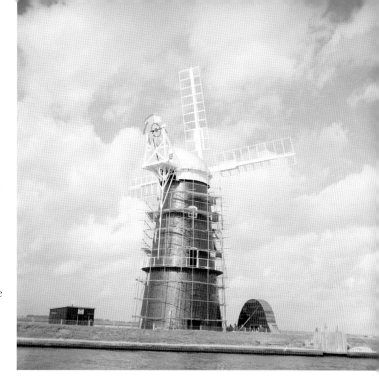

Berney Arms
A restoration programme began at Berney Arms Mill in 1967. This photograph, taken the following year, shows the project underway and scaffolding in place. Getting materials and equipment to the site must have been challenging as Berney Arms is not easily accessible. The railway station is one of the most remote and least used in the country. The post office, which had operated from the station, had closed down a year before this photograph was taken. (Historic England Archive)

Sprowston, Norfolk
A rare photograph from 1933. The brigade is attending a fire at Sprowston. The post mill at Sprowston had once been a magnificent sight and had become a favourite subject for artists. It was completely destroyed by the 1933 fire, but it lived on in the community. Bricks recovered from the fire were used for garden walls in the area, the timbers were turned into various artefacts, and today the mill appears on Sprowston's parish sign. (Historic England Archive)

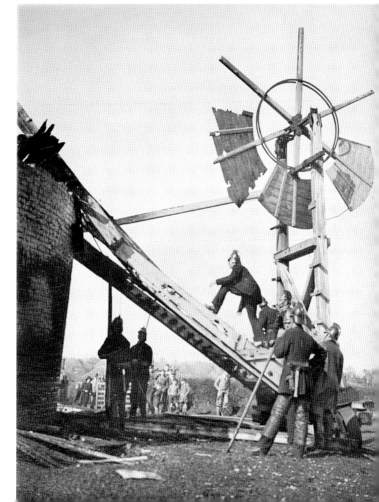

Above: Denver, Norfolk
Built in 1835 and not far from the church, Denver Windmill replaced an earlier structure. It was just over a hundred years old when it was struck by lightning in 1939. A towering six storeys high, Denver Mill was converted to be partly diesel powered in the 1930s and by the 1940s it used no wind power at all. It has undergone much restoration since, but in this 1956 shot it appears complete and set in a landscape of almost timeless rural tranquility. (© Historic England Archive)

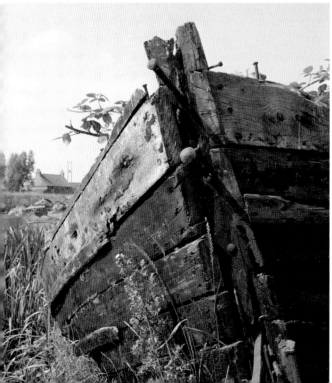

Left: Denver, Norfolk
Timelessly resting and slowly rotting away, this wooden boat was presumably already of a certain age by the time it was photographed in a field at Denver in 1956. (© Historic England Archive)

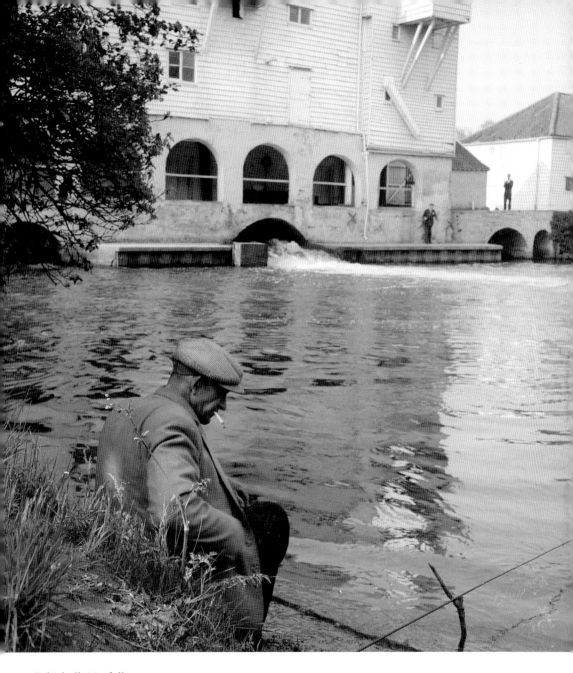

Coltishall, Norfolk

The great mill at Horstead was built in the late 1700s, although there had been mills on the same site for centuries. The angler in this 1956 picture can have no idea that, just seven years later, in 1963, Horstead Mill will be gutted by fire. Believed to have been started by an electrical fault, the blaze swept through the mill at an astonishing speed. Ironically, the fire occurred during the legendary 'big freeze' of the record-breaking harsh winter of 1963. The fire brigade had to cut holes in the ice on the frozen river to get access to water – and still the hose nozzles froze over. Despite the conditions the brigade, who had brought three engines, managed to get the fire under control within an hour. It was too late though. The damage was so great that the mill could not be saved. (© Historic England Archive)

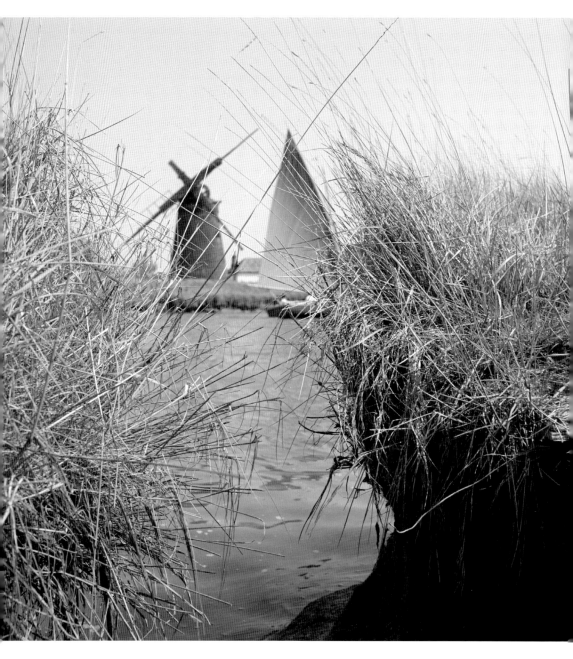

Mautby, Norfolk
A mill, a sail and the reeds. A definitive shot of Norfolk taken at Mautby Drainage Mill in 1956. Just over 6 miles from Great Yarmouth and 19 miles from Norwich, this small Norfolk village sits in a parish on the banks of the River Bure. Margaret Paston, of the family who wrote the world famous Paston Letters, was buried in Mautby. When the Victorians renovated the then badly decaying church her remains were moved. As a result, today their exact location is unknown and unmarked. (© Historic England Archive)

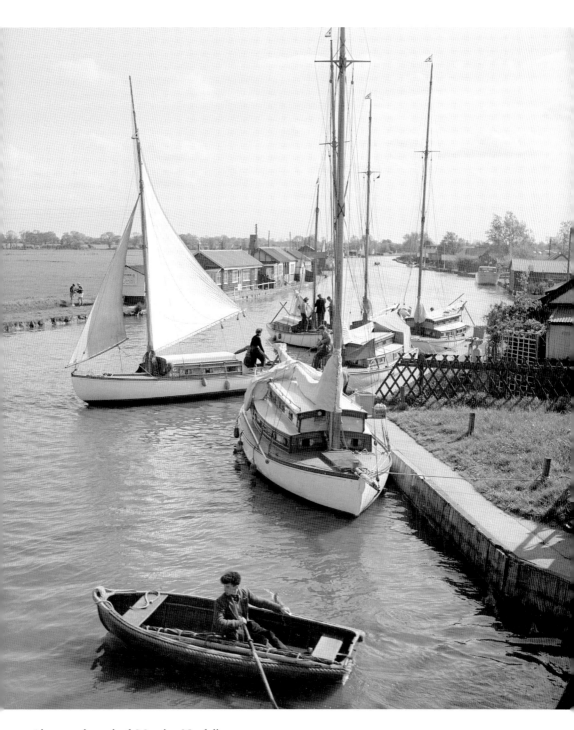

Above and overleaf: Mautby, Norfolk
A series of pictures at Mautby from the same day in 1956. The wide horizon, the big sky, the water, it's another set of timeless pictures of Norfolk. (© Historic England Archive)

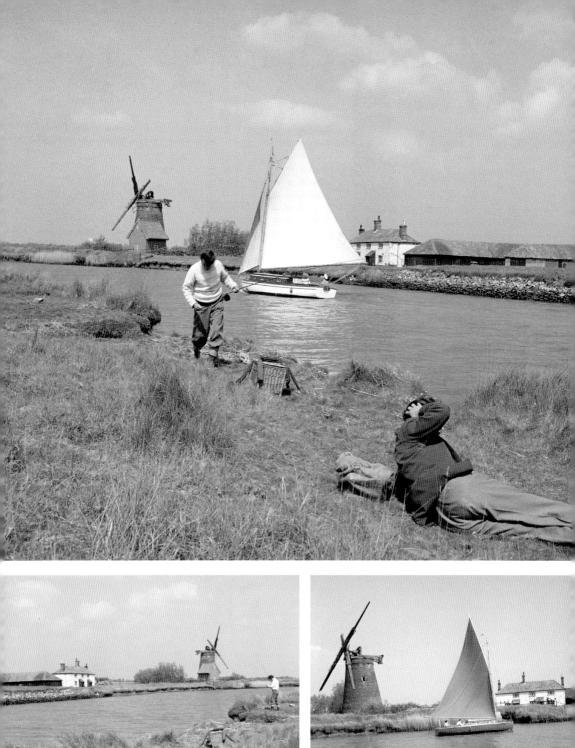
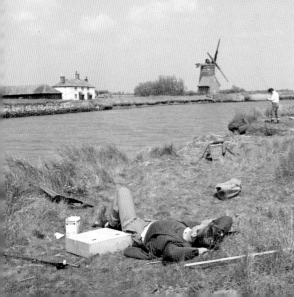
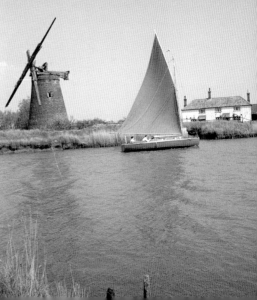

Broads, Boats and Rivers

The Norfolk Broads had long since become a popular destination for holidaymakers, but it was the 1950s before it was accepted that they were man-made. The fact that they are flooded peat diggings from the Middle Ages has done nothing to detract from the enormous and popular appeal of Norfolk's world-famous waterways. Quite the contrary. There are roads and railways, towns and villages in the county, but it's the Broads and their boats and rivers that, for many, define the look of Norfolk.

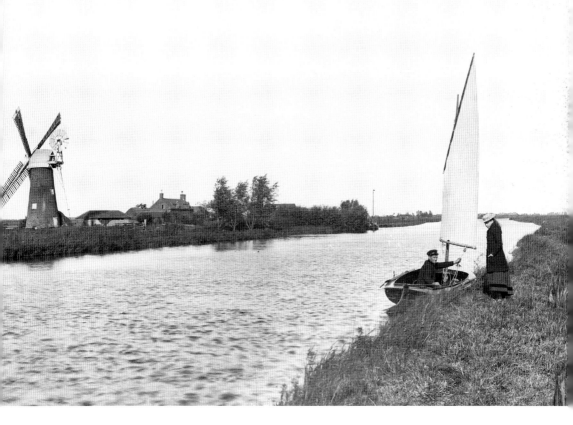

Stalham, Norfolk

If evidence was needed that life on Norfolk's waterways had remained timeless, this is it. It's Stalham, just 12 or so miles from Mautby. Just like the Mautby pictures this shot features boats, a tower mill and the water. This Stalham picture, though, was taken in 1894. Given that Stalham is old enough to be mentioned in the Domesday Book, it's fitting that today it is home to the Museum of the Broads. (Historic England Archive)

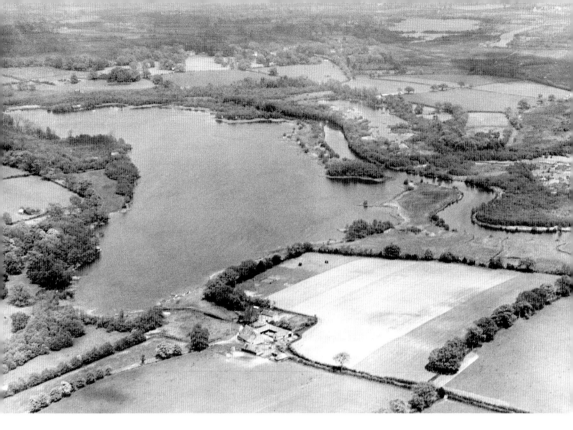

Above: Wroxham, Norfolk

A bird's-eye view of Wroxham. This photograph dates from 1928. It's strange that by then technology had developed to embrace powered flight and aerial photography such as this, but we were still far from sure about the man-made origins of the Norfolk Broads. At this point in the 1920s it was still generally believed that the Broads were natural lakes. It would be the 1950s before Dr Joyce Lambert published her findings and proved that they were indeed flooded peat diggings from the Middle Ages. (© Historic England Archive. Aerofilms Collection)

Opposite above: Potter Heigham, Norfolk

An aerial shot from ten years later, in 1938. It shows the Broads village of Potter Heigham. The place is famous for its bridge, which, dating from the fourteenth century, is not only ancient but difficult to navigate. During the First World War the nearby Hickling Broad was a seaplane base. During the Second World War the parish of Potter Heigham included an airbase. This picture dates from the interwar period, which saw a boom in Norfolk Broads holidays. Even though tourism was increasing, agriculture had remained essential and central to the Norfolk economy. (© Historic England Archive. Aerofilms Collection)

Opposite below: Wroxham, Norfolk

Another 1928 aerial view shows how much Wroxham and the area around the River Bure had developed by then. The Norfolk Broads had been increasingly popular as a holiday destination since before the First World War. The railway boom of the 1840s had brought more and more people to the area, fuelling the popularity of sailing holidays, which sat easily with the Victorian's newly rekindled love of the outdoor life. Not long after this picture was taken the increased availability of powered motor cruisers, during the 1930s, would see another dramatic increase in Broads tourism. (© Historic England Archive. Aerofilms Collection)

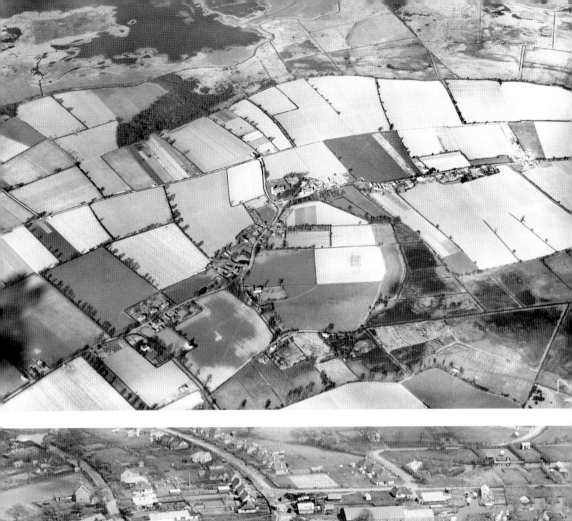
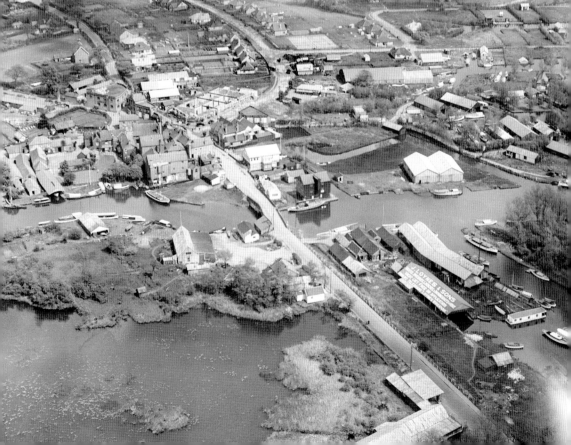

Farms and Farmers

For all its commercial and cultural importance, and despite its shifting fortunes after the Industrial Revolution, Norfolk will always be an important centre of agriculture.

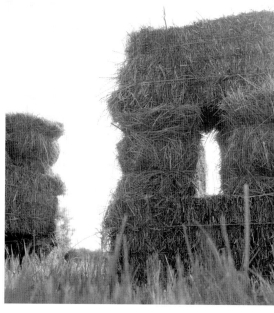

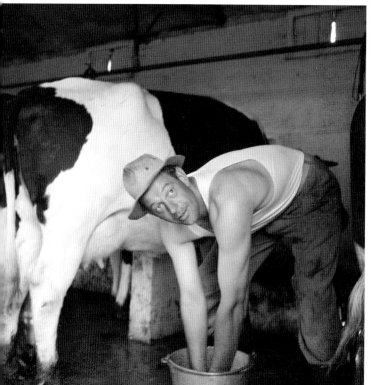

Above left and right: Farming in Norfolk
1950s photographs of hay stacked in a Norfolk field. These could have been the first stages of building more traditional haystacks, or smaller, imaginative methods. Farming was, in post-war Norfolk, a mix of ancient tradition and inevitable change.
(© Historic England Archive)

Left: Cow Milking in Norfolk
Milking cows by hand was still commonplace in the 1950s. This farmer's galvanised metal bucket appears to be the most modern part of his equipment.
(© Historic England Archive)

Toftwood, Norfolk
At the same time, a milk cooler in operation at Toftwood shows that by 1956 there were some advances in the technology of dairy farming. (© Historic England Archive)

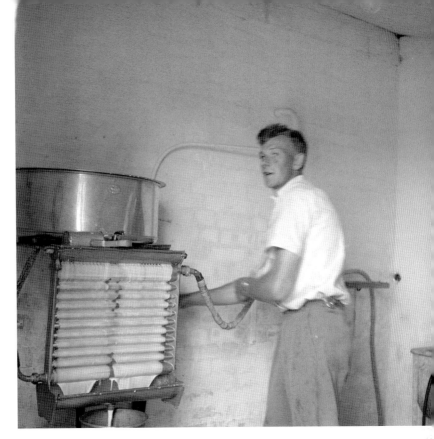

Marshland St James, Norfolk
The sense of one era coming to an end and a new one beginning is evident in several of the archive's pictures from the late 1940s and early 1950s. The Second World War was already raging when this May 1940 photograph was taken. It shows Norfolk men at work potato riddling. Warfare may have gone to a terrifyingly unprecedented level, but little had changed in this time-consuming and back-breaking process. (Historic England Archive)

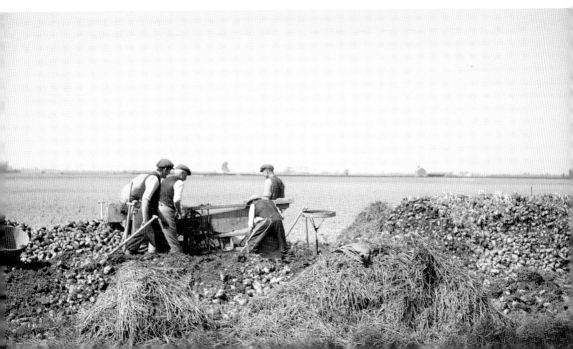

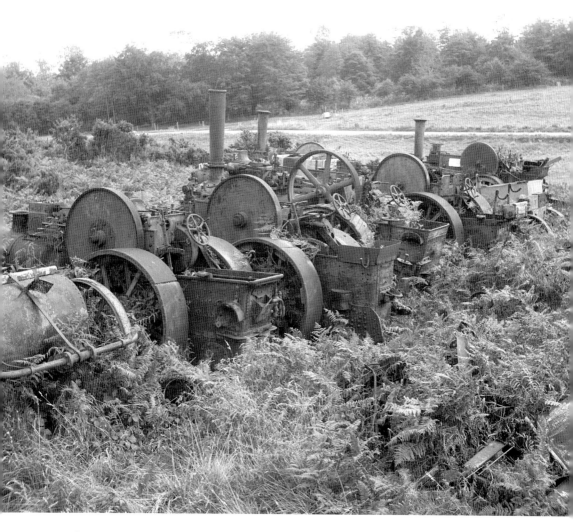

Above: Massingham Heath, Norfolk
With the war over, things were about to move on. Steam engines were already becoming outdated. This is a group of derelict machines, already decommissioned and lined up in a field in October 1946. (Historic England Archive)

Opposite above: Knapton, Norfolk
In the same year there is ample evidence of tractor power in use. This is a flax-pulling machine in use during that first summer of peacetime. During the Second World War the demand for flax had grown. It had been used to make a range of essential products including ships' sails, parachute harnesses and hosepipes. Post-war necessities would sustain demand. (Historic England Archive)

Opposite below: Costessey, Norfolk
A mixture of machinery and muscle, in this scene from 1953 there's a tractor to pull the cart, but the hay is still being lifted by hand. (Historic England Archive)

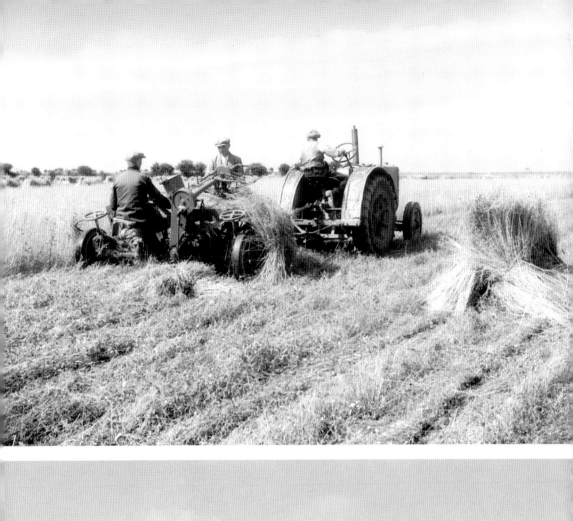

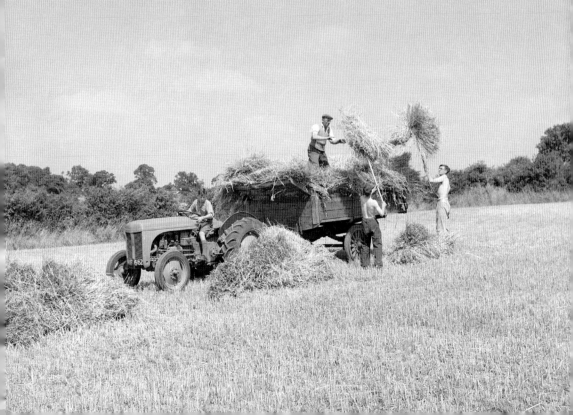

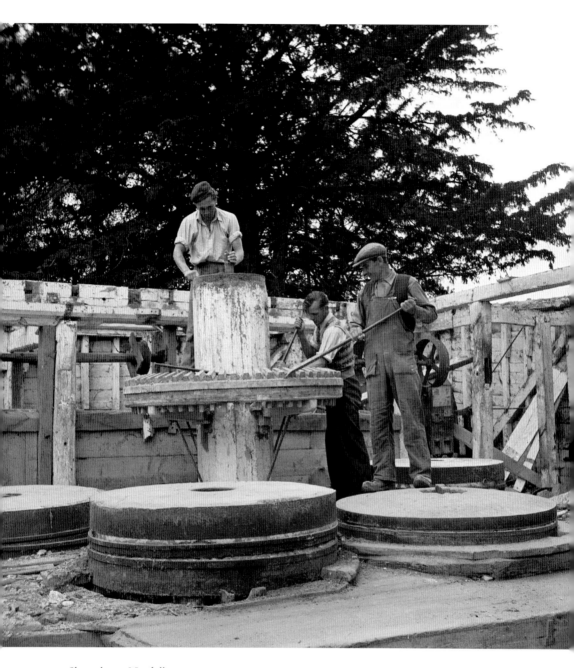

Shotesham, Norfolk
At Shotesham the watermill is being demolished in 1949. There had been a watermill here since the 1700s. By the end of the Second World War it had effectively ceased to operate. When it was flooded, the last miller having already retired, its days were numbered, although there were valiant attempts to rescue it. In 1949 the local press was carrying stories of 'an interested person' being prepared to spend 'a considerable sum of money' on it. It wasn't to be. Eventually demolition became inevitable. In this photograph workmen are removing the gearing and millstones. (Historic England Archive)

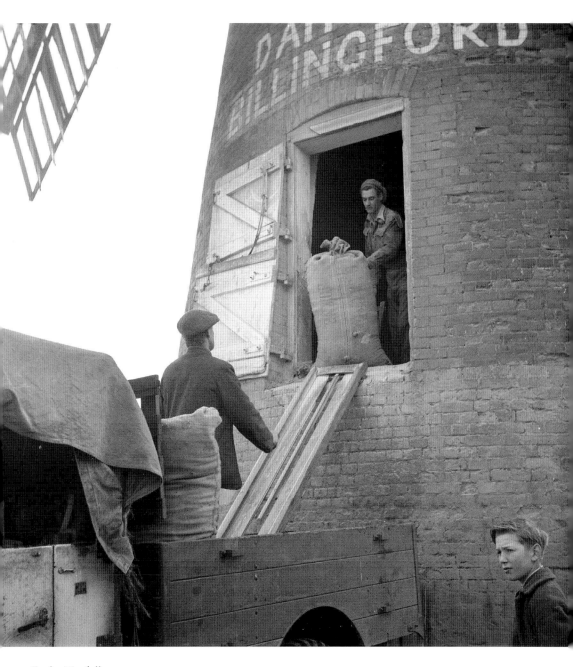

Scole, Norfolk
Scole was once directly linked to Venta Icenorum by the old Roman road. That road remained a main route until into the twentieth century when a bypass was built. In this April 1950 shot the 'old road' was still in use. Here a journey begins as sacks are being loaded from Billingford Mill, near Scole, onto a lorry. (Historic England Archive)

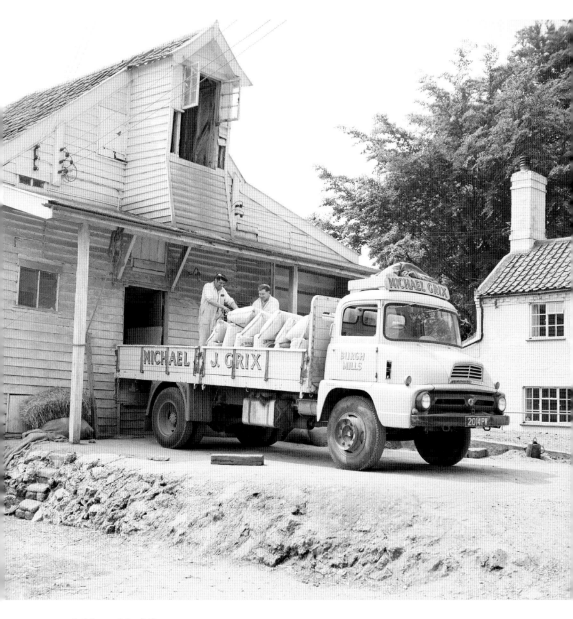

Aylsham, Norfolk
By the 1960s transport had changed. Now the lorry would become the basis of agricultural logistics and transport. Burgh Mill was a busy commercial flour mill on the River Bure. Its weather-boarded construction dated from the eighteenth century. With some evidence of a mill being on the site since the 1500s, there have been claims that Burgh was the oldest mill in Norfolk. (Historic England Archive)

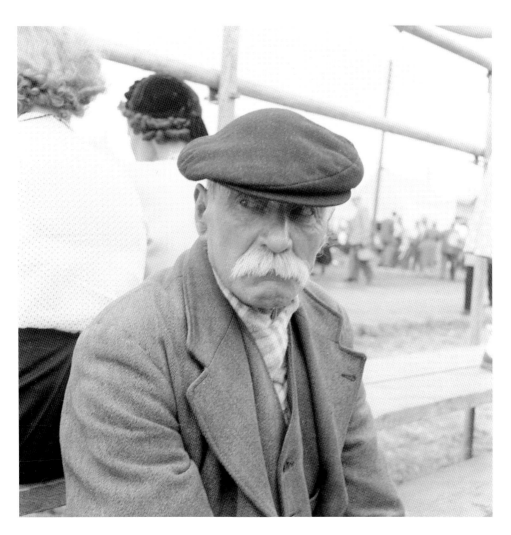

The Royal Norfolk Show
The Royal Norfolk Show is at the heart of the county's agricultural community and an important event in the commercial and social calendar. It has been held almost every year since 1847. The following photographs from the mid-1950s are interesting in that while they are now almost sixty years old, and show a world much simpler than today's, they also provide more evidence of the post-war period being a time when tradition and technological change sat side by side in the farming world.

Some characters from the agricultural community evoked a timeless style and attitude. It's worth remembering that this man, no longer young in this 1950s photograph, would have almost certainly been born in the nineteenth century. His cap, clothes and luxuriant moustache are, in their way, flamboyant, but they are rooted in the style and traditions of a time long before the 1950s. (© Historic England Archive)

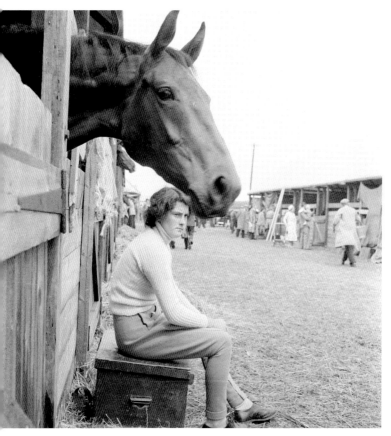

Left: Horses are always an important part of the show. Riders in the 1950s were as keen as any to show off their equestrian skills, and were, it seems, prepared to put up with the long waits between events in the main ring. The displaying of animals, at work, for sport and for exhibition, was then a vital part of the Royal Norfolk Show. It remains so, although the event has become more widespread and diverse in its appeal and participants. (© Historic England Archive)

Below left and right: A man could take a rest between jobs, while others kept their eyes on the prize. This cattle farmer has plenty of rosettes on show. (© Historic England Archive)

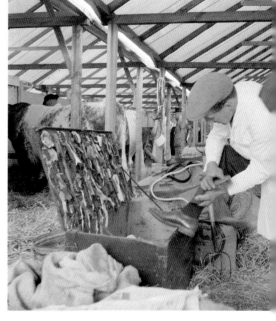

Above and right: Children are as intrigued as ever by things they find to do at the show. Today there are perhaps more activities aimed specifically at children, but there have always been things that interest the younger ones. Some of them will be the farmers of the future. (© Historic England Archive)

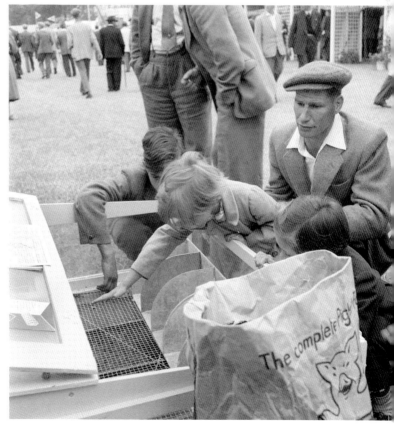

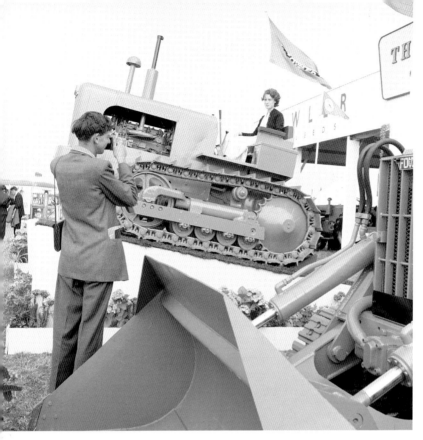

The future of farming is evident in some of the displays. Powered machinery and impressive stands herald a new era for the Royal Norfolk Show, and the agricultural scene in general. (© Historic England Archive)

Buildings and Business

Norfolk is the birthplace of many businesses. The famous Colman's mustard brand was founded here, as was Norwich Union, which went on to become Aviva. This place may not have been where the mills and factories of nineteenth-century England changed the face of manufacturing and commerce, but Norfolk has always 'done business'.

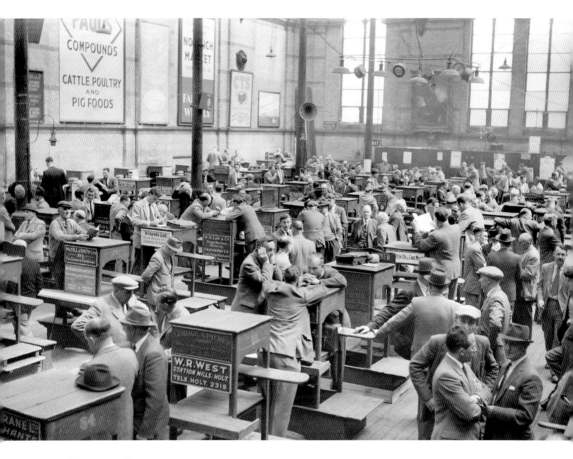

Norwich Corn Exchange

The world of agriculture has to sell its produce and a vital institution in that process was the Corn Exchange. This was the Corn Exchange in Exchange Street, Norwich, where the agricultural market operated, and where farming met commerce. This is a picture of a trading day in 1960. Just a few years later the Corn Exchange will be closed, and the building taken over by Jarrold, who will expand their London Street and Exchange Street department store into the space. The business of the Corn Exchange will be moved to the new cattle market at Harford Bridges. Modern, concrete and out of the city centre, the new cattle market would draw criticism from many quarters, although the farmers praised the safety and convenience of the new site. (Historic England Archive)

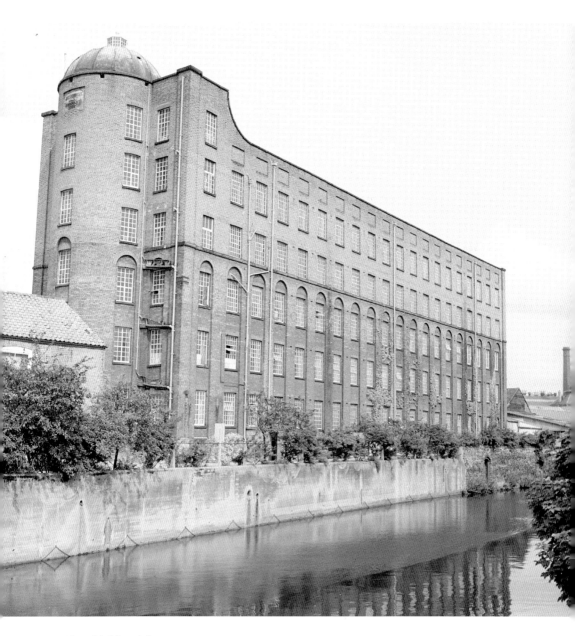

Jarrold, Norwich
Jarrold had bought St James Mill at the start of the twentieth century. They needed more space to expand their printing operation. The mill had originally been built in 1834 by Samuel Bignold, who had envisioned it as a means of rekindling the Norwich textile industry. Fragile finances meant that the enterprise had failed. The building, though, would survive and become the home of several important companies, notable among them Jarrold and Caleys. It also became a centre for retraining soldiers after the First World War. This picture shows the mill in 1956. Today it is home to the John Jarrold Printing Museum. (Historic England Archive)

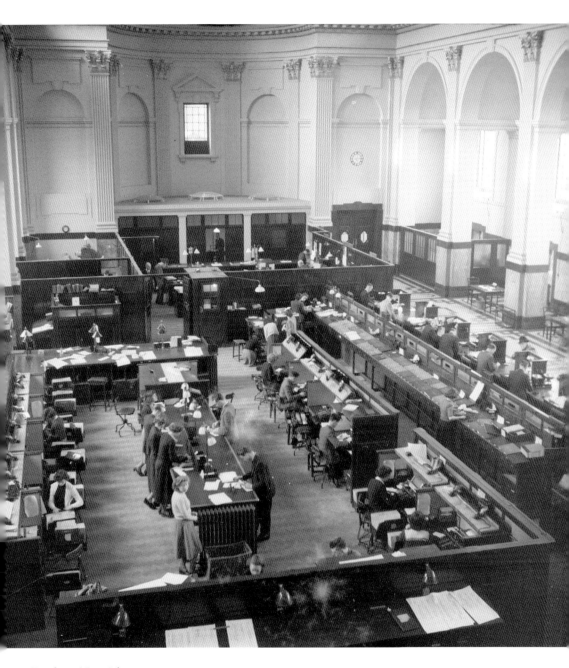

Barclays, Norwich

Jarrold, many farmers and countless individual customers used Barclays Bank in Norwich. A worldwide organisation today, it is one of those famous international businesses with Norfolk origins. Its heritage is rooted in Gurneys Bank, which was founded in Norwich in the eighteenth century. This is Barclays Banking Hall at Bank Plain, Norwich, in 1951. It's a glimpse back into banking in the pre-computer age. (Historic England Archive)

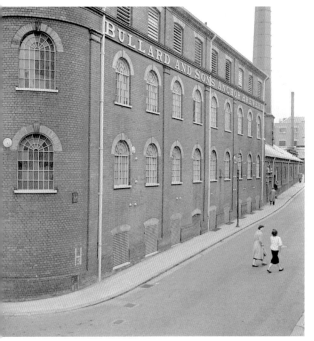

The Bullards' Anchor Brewery, Norwich
The Bullards' Anchor Brewery was still in operation until well into the twentieth century. The brewery had been founded by Richard Bullard in 1837 on this site in Norwich's Westwick Street. The business would grow to cover 7 acres of land here. It would also expand until, by 1914, they had 133 'tied' pubs in Norwich alone. Mergers, sales of shares and takeovers resulted in the brewery eventually closing down in 1966. Shown here in the late 1950s, the brewery was still producing beer for mainly local consumption. The era of the bigger brewery groups and mass-produced 'fizzy beer' had not yet arrived. In the 1970s the site was sold, although the Bullards name has been revived during recent years, along with the preference for locally produced beer. (Historic England Archive)

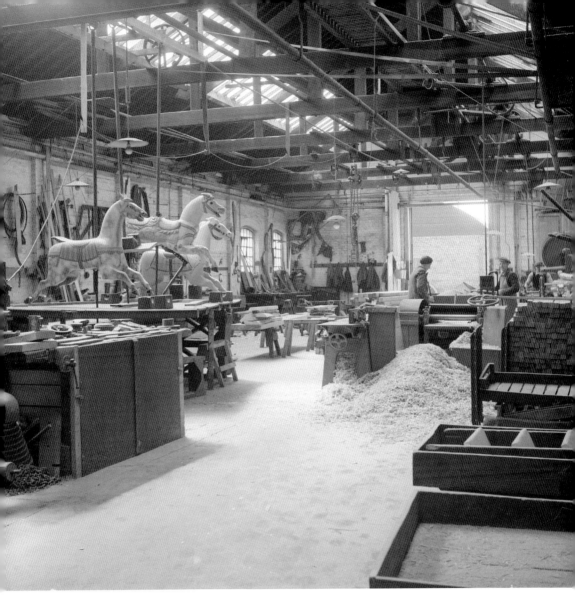

Above: Kings Lynn
Savages Works, where carpenters are making wooden fairground horses for a carousel. (Historic England Archive)

Opposite below: Fakenham
Industrial and commercial buildings were not confined to the city of Norwich. The industrial and agricultural revolutions had each made their mark on the county, and this 1960s photograph of Fakenham shows both the corn mill on Hempton Road and the retort house of the gasworks. Today the the Fakenham Museum of Gas and Local History is important as the country's only surviving town gasworks. The museum features all the machinery and equipment once needed to make gas from coal, including retorts, the condenser, purifiers, meter and the gasholder. (Historic England Archive)

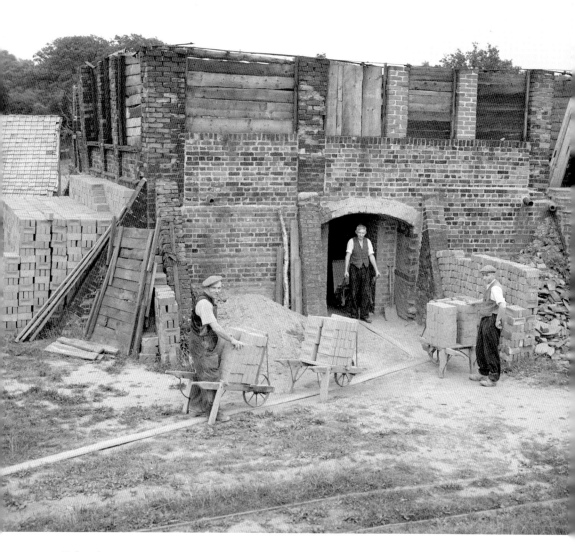

Fulmodeston
Fulmodeston is a large parish formed by the amalgamation of several smaller ones. Industrial brick making here can certainly be traced back to the nineteenth century, and it possibly goes back much further. The clay beneath the soil in the area is extremely suitable for brick making and some research suggests that the process was being carried out here even before the medieval period. These men, at their brick kilns near Fulmodeston, were photographed in 1952. (Historic England Archive)

Markets

Commerce, especially in a largely rural county, has been centred on the marketplace for centuries. Long before the term was used metaphorically in the language of business, the marketplace was, and in many places still is, the tangible heart of a community.

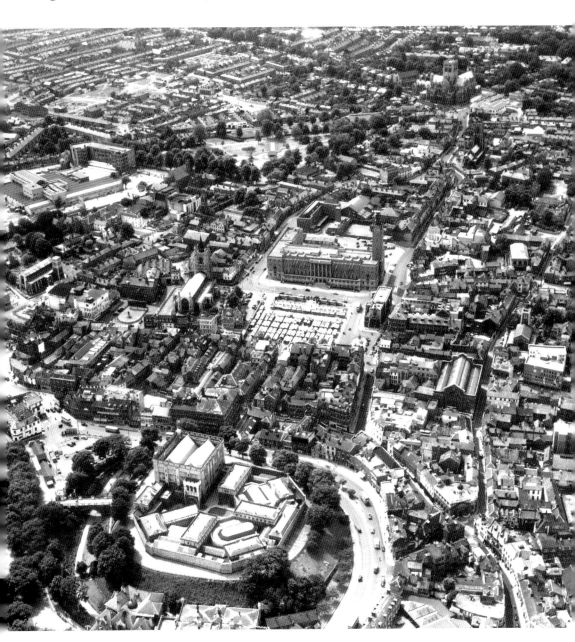

Norwich

Not long after the 1066 invasion the Normans settled in Norwich where they built a castle and a cathedral. For their cathedral they wanted the land then used by the local Saxon population as a market. As a result, the market was moved to be within sight of the new castle. The city's commerce would then be carried out under the eyes of the new rulers. This stunning aerial shot from 1951 shows both castle and market, both of which had survived, and are still there today.

Norwich marketplace 'still being there' means it's traded on this site for over 900 years. Initially the market provided for the merchants and travellers of Norman society. By the fourteenth century, when Norwich had become a very important city, second only to London, the market was a significant centre of trade. When the monarch gave control of the market to the city in 1341, it provided a considerable income to Norwich and created the freedom to plan how the market was organised and laid out. That 'blueprint' was the basis of the market today. It was to some extent reorganised in the 1930s, by which time it was largely in public ownership. By the start of the twenty-first century there were concerns over the condition of the market and its stalls. Initial plans for refurbishment were abandoned in 2004 and a new scheme was implemented, coming to fruition in 2006. Now the striped stalls form one of the country's biggest markets.

Norwich market features quite a lot in the archive, and the shots that follow from the 1940s capture the period when, after the Second World War, the 1930s plan was still in place. (© Historic England Archive. Aerofilms Collection)

Below: This 1946 shot was taken from the City Hall. The art deco City Hall had been completed in 1938. (Historic England Archive)

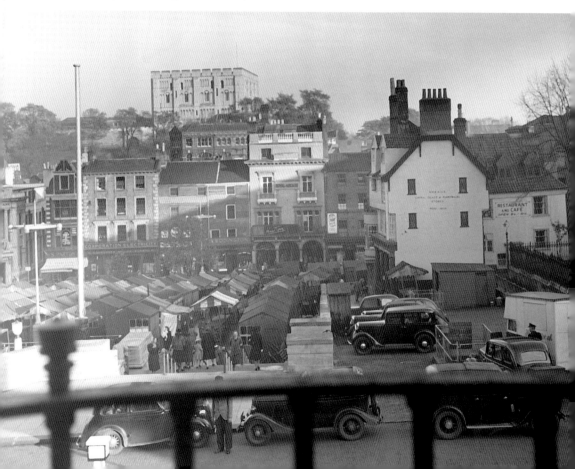

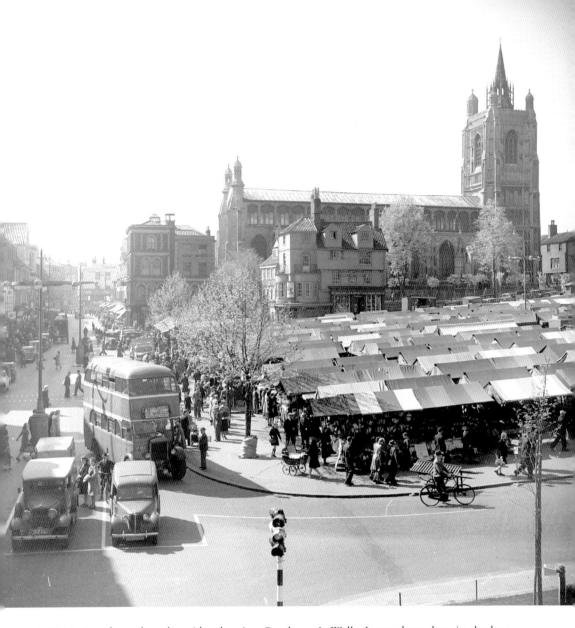

A 1948 view from the other side, showing Gentleman's Walk. It was here that, in the late eighteenth and early nineteenth centuries, the shops and coaching inns were established. Norwich experienced considerable growth during the Georgian era. (Historic England Archive)

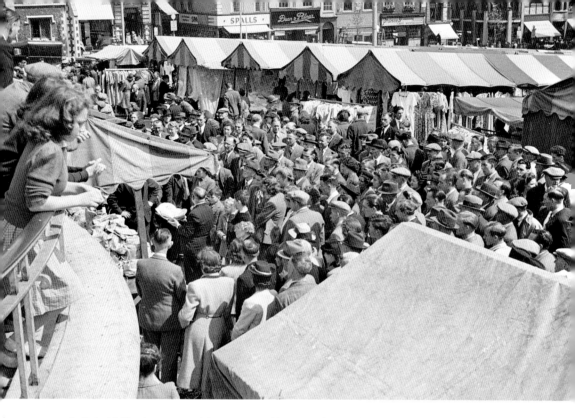

In July 1948 a large crowd is entertained by a market trader pitching his wares. The theatrical presentation of stall holders, often juggling crockery as part of the presentation, was quite a market tradition. (Historic England Archive)

Outside what had been the Agricultural Hall until Anglia Television moved in during the late 1950s, Norwich still had its cattle market in the city centre. Every Saturday cattle were herded though the city streets to be sold from pens that were removed for the rest of the week. Once or twice a year – at Easter and Christmas – this site would play host to the 'the Fair'.

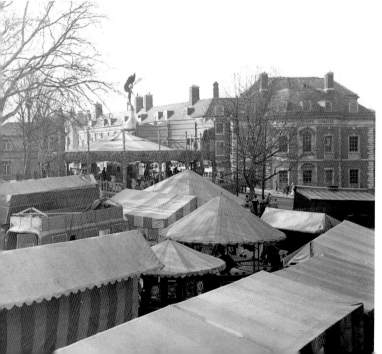

March 1948 and the cattle market is set up for the Easter Fair. The Barclays branch on Bank Plain can be seen in the background. (Historic England Archive)

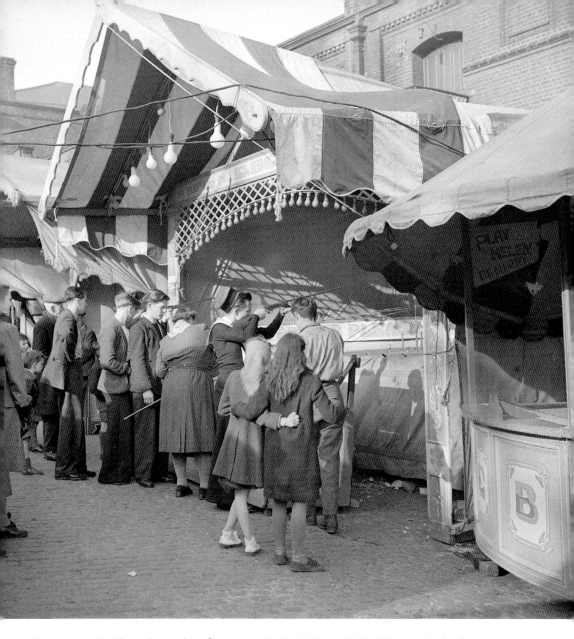

Young and old alike gather at the rifle range at 'the Fair', Easter 1948. (Historic England Archive)

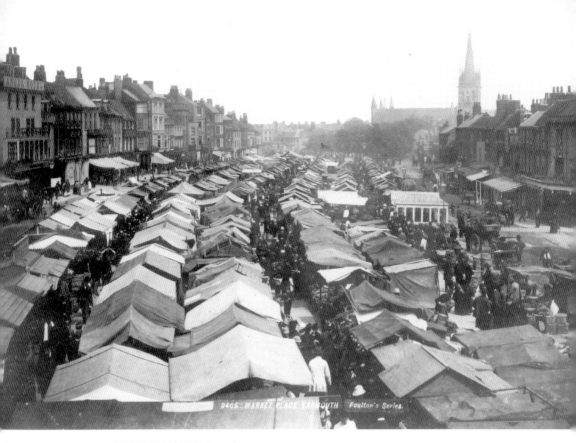

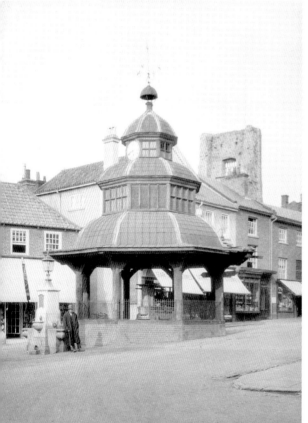

Above: Great Yarmouth
The marketplace in Great Yarmouth is another ancient place of trading. It was granted a charter by King John in 1208 and was certainly there in some form before that. The first market cross was erected here in 1385. It survived until 1509 when it was replaced with a new one. There would be others until the last one was taken away and sold in 1836. A bag of chips was a favourite hot snack from the stalls on Great Yarmouth market for decades. Oddly it wasn't until 2016 that the market's charter was altered to allow the sale of fried fish to go with them! This fascinating archive photograph is dated 1897. (Historic England Archive)

Left: North Walsham
Another relatively early photograph. Taken in 1925, this one shows the market cross at the centre of North Walsham. Truly a market town, North Walsham had been important for its weaving as early as the Anglo-Saxon period. (Historic England Archive)

Right: Downham Market
This is the market in the centre of Downham
Market, a town granted market status
as early as 1050. It makes it one of the
oldest market towns in the country. It's
said that the clock, presented to Downham
Market by James Scott, a local grocer, has
had only one refurbishment since it was
installed in 1878. This 1972 photograph
shows it surrounded by the increasing
traffic of the twentieth century.
(© Historic England Archive)

Below: Downham Market
This aerial photograph of Downham Market
dates from 1928. (© Historic England
Archive. Aerofilms Collection)

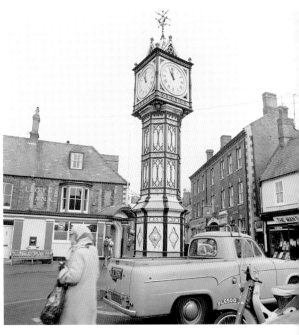

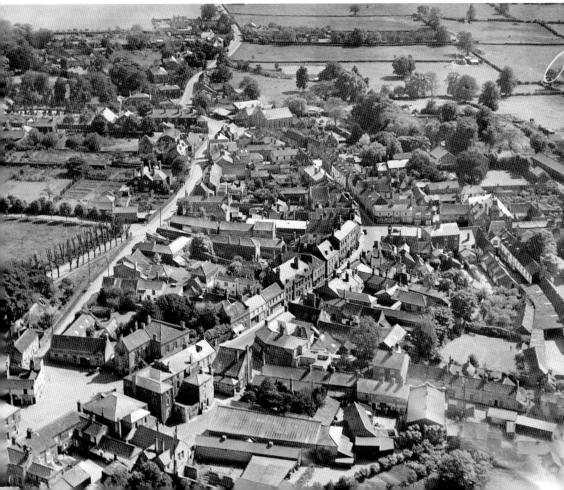

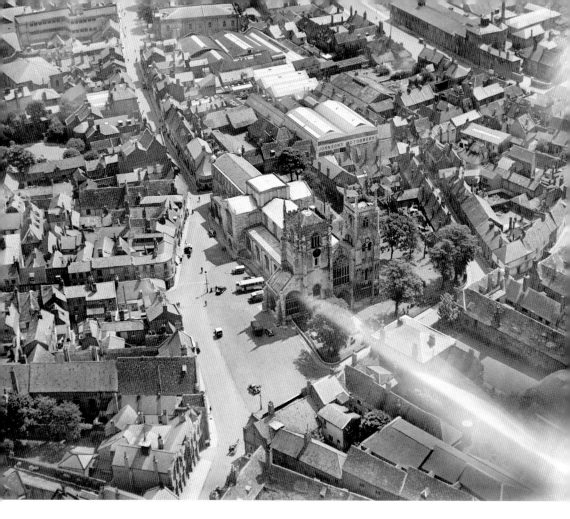

Above: King's Lynn
There is evidence of a 'sand market' being held at King's Lynn's Saturday Market Place as early as 1104. The place comes up again in records from 1205 when a charter was granted. This aerial picture is a vintage piece itself. Dating from 1928, it shows the Saturday Market Place and St Margaret's Church. (© Historic England Archive. Aerofilms Collection)

Opposite above: King's Lynn
A more down-to-earth shot of the same King's Lynn location in 2017. (© Historic England Archive)

Opposite below: Wymondham
Another shot from the 1928 aerial sequence shows Wymondham town centre. Badly damaged by the town's great fire in 1615, Wymondham was effectively recreated only to see its fortunes dashed by the collapse of the woollen industry in the nineteenth century. In the meantime the town's most famous inhabitant, Robert Kett, had led the rebellion of 1549 during which his forces held the city of Norwich for six weeks. He was executed at Norwich Castle. (© Historic England Archive. Aerofilms Collection)

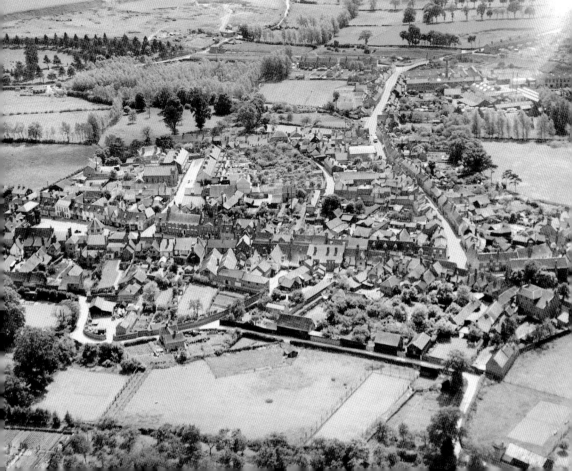

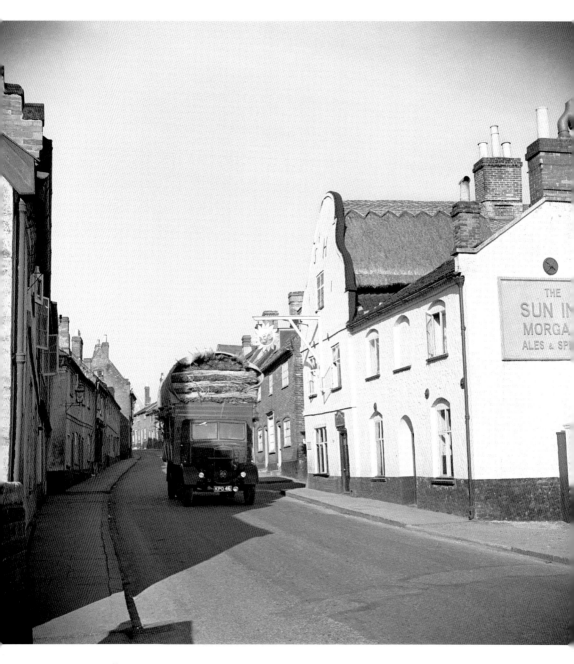

Wymondham
Twenty years on from the aerial picture (previous page), this is Wymondham in 1949. A normal working day in a quieter era than now, a lorry is carrying its load of Norfolk reeds. (Historic England Archive)

Crafts and Trades

These photographs from the archive show that many of the crafts and trades in Norfolk remained unchanged for decades.

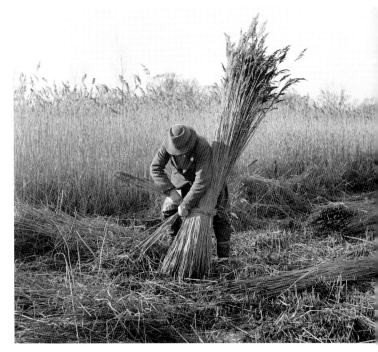

Woodbastwick Marshes Cutting and bundling reeds is a part of Norfolk history. These pictures from 1949 are all but timeless. (Historic England Archive)

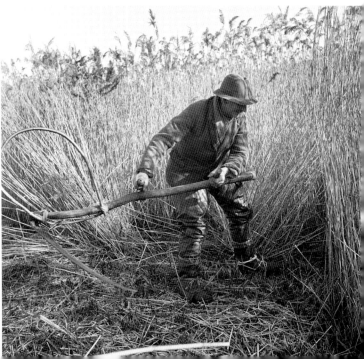

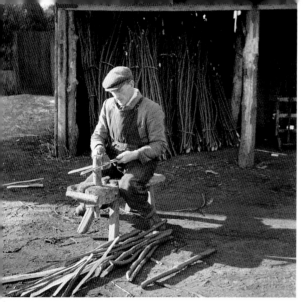

Above left and right: Salhouse
The top left picture depicts willow or hazel whithies being split, probably to make hurdle fences or broaches for reed thatching. The top right picture shows a gentleman shaving the bark off round wood timbers for purposes unknown. These 1949 photographs could have been taken decades earlier. Thatching may not have been as ubiquitous in Norfolk as it's perceived to be but it has long been a local skill. (Historic England Archive)

Below: Mautby
Horses, always part of rural life, seen here at Mautby Marsh. (© Historic England Archive)

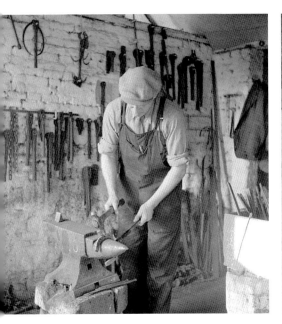
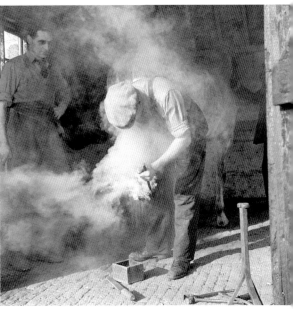

Above left and right: Woodbastwick
A constant throughout the centuries is that horses always need tending and shoeing. By February 1949 the blacksmith's forge at Woodbastwick was still much the same as it had been for generations. (Historic England Archive)

Below left and right: Fulmodeston
Hand-making bricks and stacking them. Some 1952 photographs showing more details of brick making at Fulmodeston. It appears to be another trade that's little changed across the centuries. (Historic England Archive)

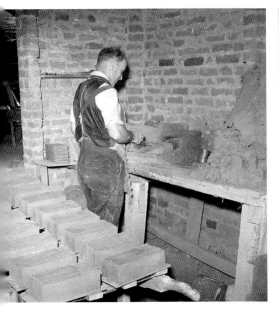

Above: Wroxham
Boatbuilding is an intrinsic part of Norfolk life. Traditional skills are still in use here in 1947. (Historic England Archive)

Opposite above: Horning
Boat construction well underway at Wilds Boatyard in 1963. (Historic England Archive)

Opposite below: Norwich
One essential trade that, despite mass-production methods, is still in demand. The baker at work in 1968. Loaves are being prepared in the bakery before being put straight into the shop 'out front'. (Historic England Archive)

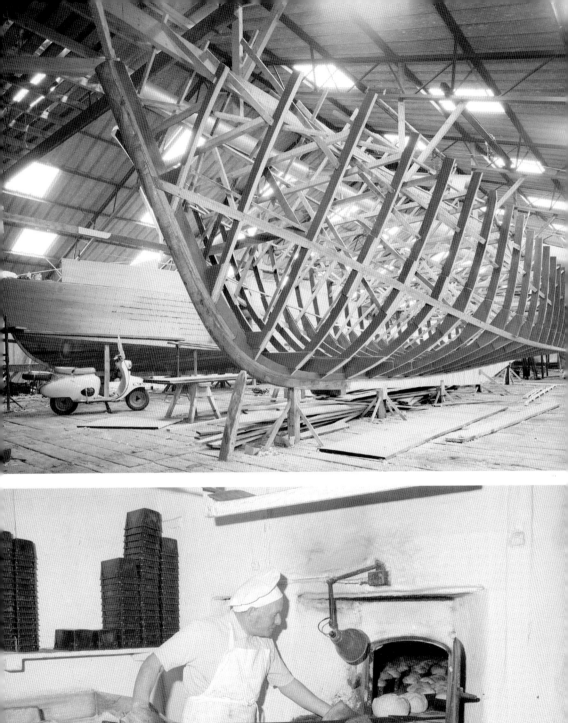

Village Shops

Villages had their own, often small, shops. Some were specialised, while others sold everything. The towns, of course, especially post-war, could offer even more choice from the bigger and increasingly national retailers.

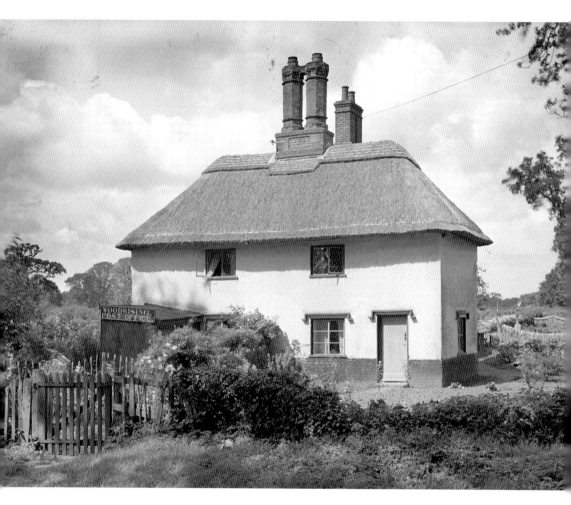

Above: Cranworth
Not exactly bristling with signage, the old post office at Woodrising, Cranworth, is photographed in 1948. Like many post offices of its kind, it had started life as a cottage and would return to being one. (Historic England Archive)

Opposite below: Rougham
While traffic was not exactly heavy at the time, the 1940s and 1950s saw an increase in motor vehicles. In this 1956 shot a shopkeeper uses his van to make deliveries to the village of Rougham. (© Historic England Archive)

Norfolk
This tobacconist's shop is in an unidentified village. It's another example of the almost anonymous nature of village shops in times gone by. People knew which house in the village was the shop, so signboards were unnecessary. The picture is from 1956.
(© Historic England Archive)

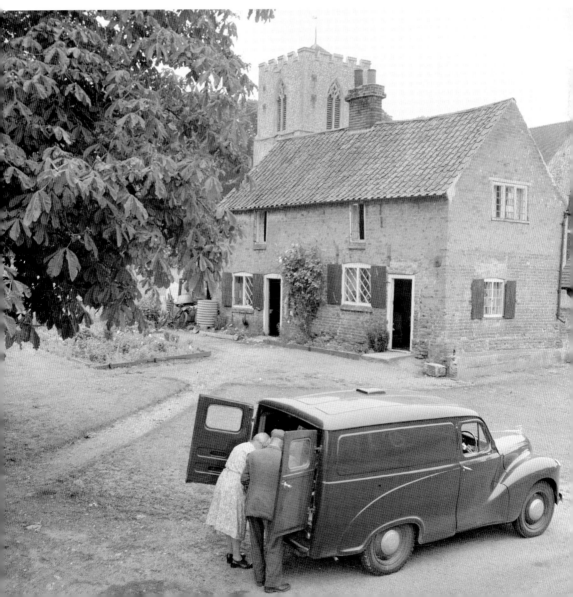

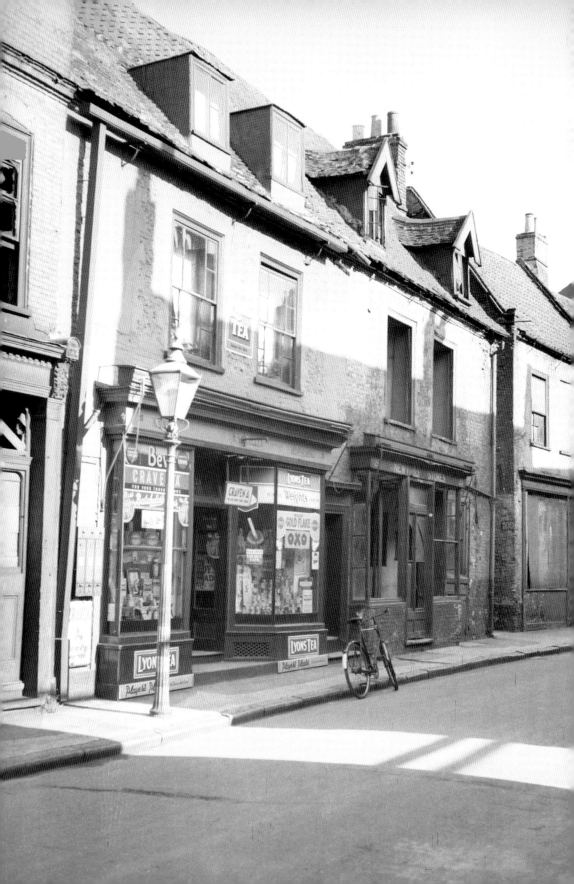

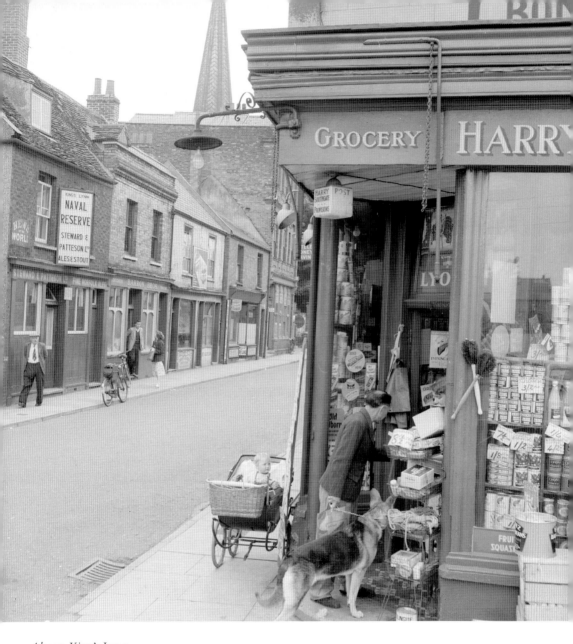

Above: King's Lynn
Harry Southgate's shop in St Anns Street appeared to be the epitome of the well-stocked 1950s 'open all hours' grocery shop. (© Historic England Archive)

Opposite: Great Yarmouth
Just after the Second World War, in 1946, this shop in Great Yarmouth's Middlegate Street seems to be defying the trend. It looks to be open for business while the rest of the street is empty and derelict. (Historic England Archive)

Above: Ludham

Few village shops were more specialised than the saddlers. By 1956, however, this one in Ludham seemed to have diversified into all manner of hardware to meet the demands of the increasingly sophisticated consumer. (© Historic England Archive)

Opposite: North Walsham

The London Central Meat Company, however, in 1930s North Walsham had steadfastly remained as a butchery specialist. The company was started by a Mr Lea and a Mr Lowe, in Tamworth, in the 1890s. It grew into a big organisation with an impressive number of branches before changing its name in 1964, when it became known nationally as Baxters. (Historic England Archive)

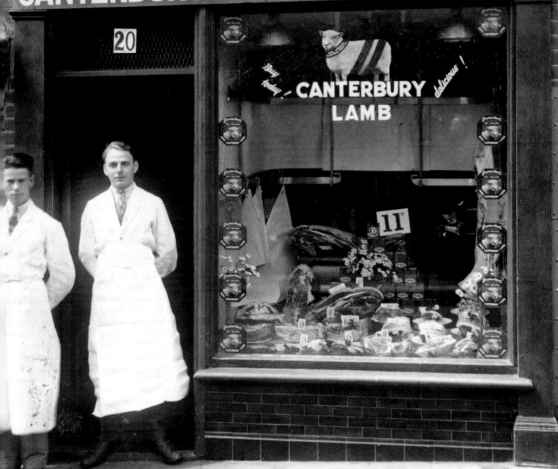

THE
LONDON CENTRAL MEAT Co LTD

CANTERBURY LAMB A SPECIALITY

20

CANTERBURY
LAMB

Buy today! delicious!

11D

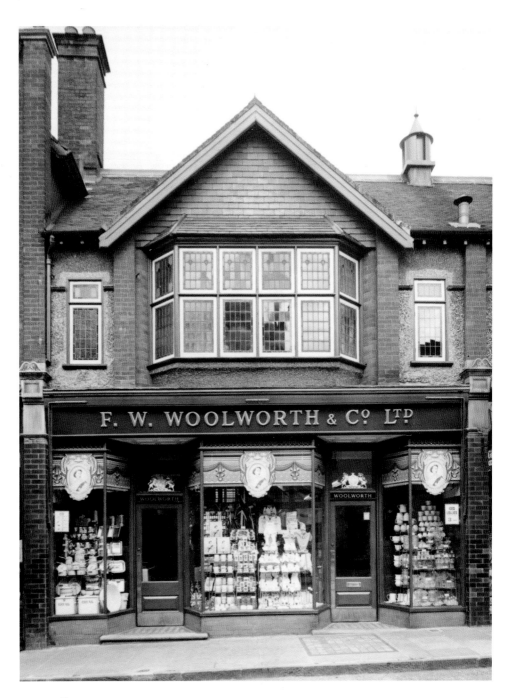

Wymondham

As brands go 'Woolies' had already become a national treasure. This is Woolworth's original premises in Wymondham – No. 39 Market Street. It's 1953 and the classic Woolworth shop frontage has not yet been adopted. There is, however, much window display material to celebrate the coronation of Elizabeth II. (Historic England Archive)

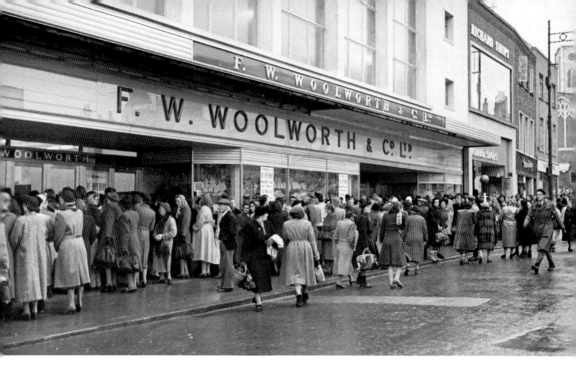

Above: Norwich
In Norwich, by 1960, the familiar appearance of F. W. Woolworth had been applied to the new frontage of the Rampant Horse Street store. (Historic England Archive)

Below: Norwich
By 1990 the Woolworths store in Norwich had been moved to St Stephens Street, and the new branch had the next new branding. The company's other branch in Norwich, in Magdalen Street, had not been revamped so much and had ceased trading in 1975. Legendary retailer Woolworth has long had a presence in Norfolk. These three images show something of how the store developed, often at the expense of the smaller shops. There was more on offer, and people had become more mobile, meaning that their shopping was not restricted to their home village. (Historic England Archive)

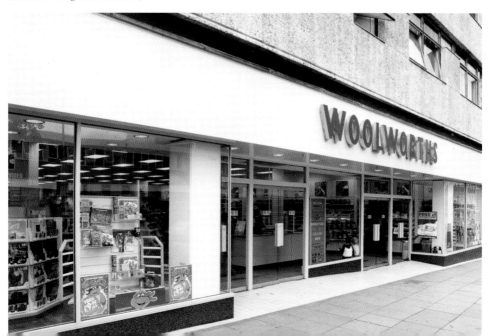

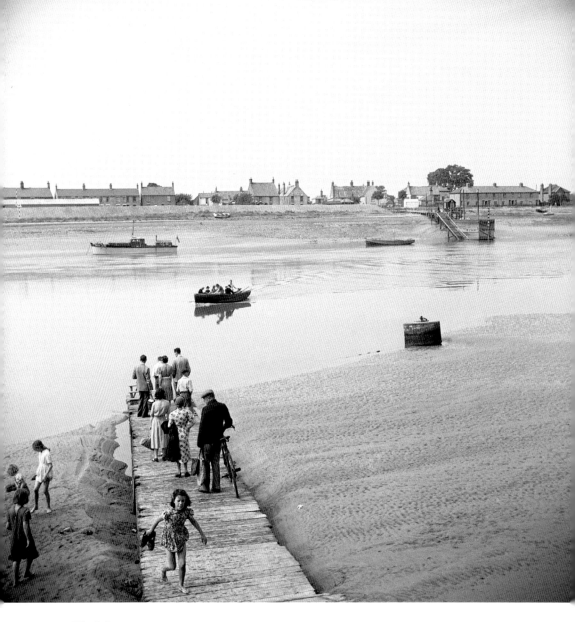

King's Lynn

Getting around Norfolk may have become easier with better roads and more vehicles, but the county's geography meant that ferries were, in some places, still a necessity. The above image, from August 1949, shows a queue for the ferry to West Lynn, across the Great Ouse. This means of getting from West Lynn to the centre and quayside of King's Lynn has origins that can be traced back to 1285. (Historic England Archive)

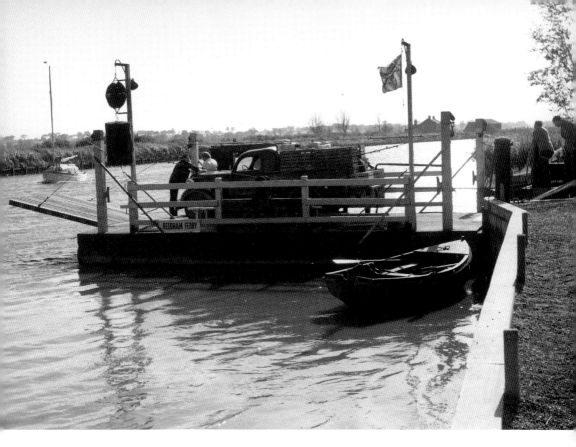

Reedham

A van is being carried by Reedham Ferry in September 1954. The chain ferry is the only way across the River Yare between Norwich and Great Yarmouth. The current ferry, capable of carrying three cars and built in 1983, is the last remaining vehicle ferry in the county. (Historic England Archive)

Pulham St Mary

In matters of transport the tiny Norfolk village of Pulham St Mary has a place in history. This plaque, on the plinth of the village sign, commemorates the R34 and its two-way crossing of the Atlantic. Pulham St Mary has strong links with airships. The village had been selected as the location for an airship base before the outbreak of the First World War. Even the purchase of the land was shrouded in secrecy to avoid potential enemies gathering intelligence. Used during the First World War for military purposes, the airships became luxurious passenger craft in the period between the wars. Ultimately they proved too dangerous and faded into history. (© Historic England Archive)

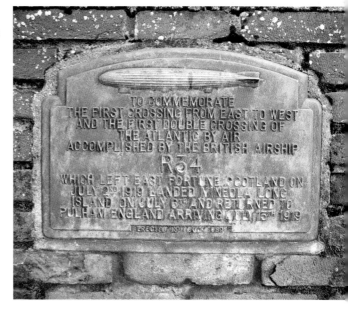

Railways

The nineteenth-century railway boom had a significant impact on the county's transport. Historic England's archive includes several pictures of Norfolk's railway stations, capturing them before the Beeching cuts to the branch lines that had served so many towns and villages.

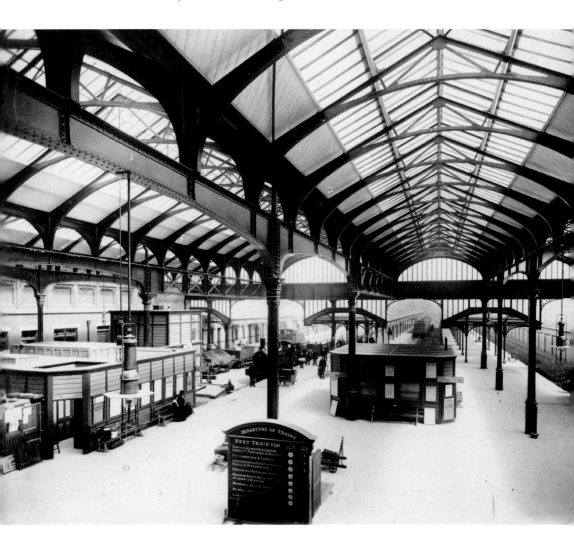

Norwich

An 1880s photograph of the then still new Norwich Thorpe station. Opened in 1886, this handsome station was designed by J. Wilson and W. N. Ashbee to replace the earlier terminus that had been built in 1844. The need for a new station was a reflection of the growing demand for railway travel and transporting of goods. Taken soon after the station was opened, this is almost certainly an official publicity shot. The platforms have obviously been cleared for dramatic photographic effect and the new destination boards are given due prominence. (Historic England Archive)

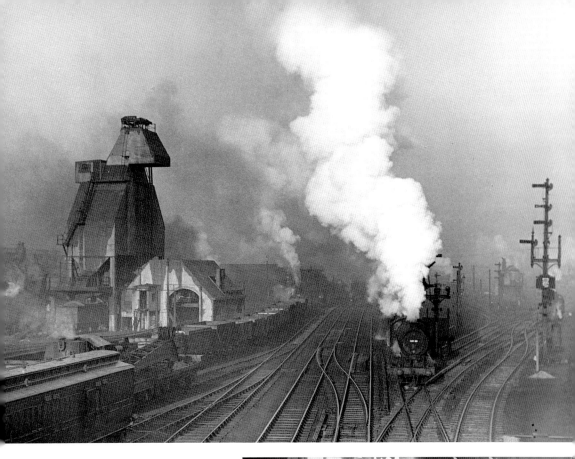

Above: Norwich
Into the next century and this dramatic 1952 photograph, looking north-west from Carrow Bridge, captures the busy, steam-powered, sometimes grimy world of the mainline post-war railways. (Historic England Archive)

Right: Sheringham
The rural lines were calmer, but not without their own special charm. This is Sheringham station. Eventually replaced in the 1960s, this building was opened in 1887. In this beautifully lit image from 1959, passengers wait for incoming trains and a lone trade bike is propped against a canopy post. The arrival of the railways had played an important part in Sheringham's history. It made it possible to transport locally caught fish, crabs and lobsters to the London markets. (© Historic England Archive)

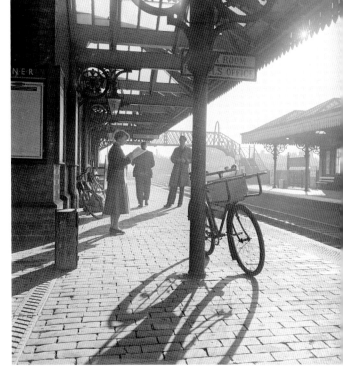

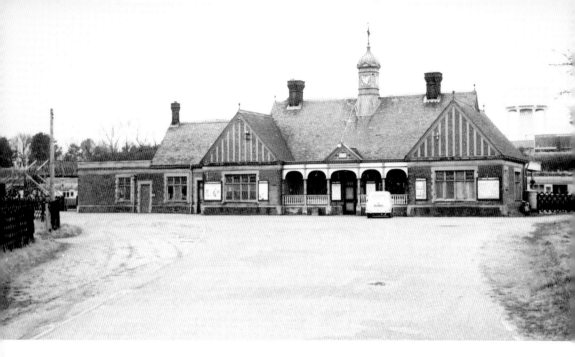

Above: Mundesley, Norfolk

Just along the north Norfolk coast, Mundesley also had a Victorian railway station. Operational from 1898 to 1964, it became the terminus of the North Walsham line in the 1950s because the Cromer line had been closed. Mundesley and its branch line were typical victims of Dr Beeching's drastic cuts. This image, with only the car in the foreground dating the picture to the 1960s, is from the station's last days. (Historic England Archive)

Below: Hunstanton, Norfolk

The locomotive and rolling stock are typically Eastern Region in this pre-Second World War picture of the station at Hunstanton. In 1962 the station featured in the British Transport Films production *John Betjeman Goes By Train*, in which the future Poet Laureate travelled to Hunstanton from King's Lynn, describing his journey and his love of railways and Norfolk on camera. (Historic England Archive)

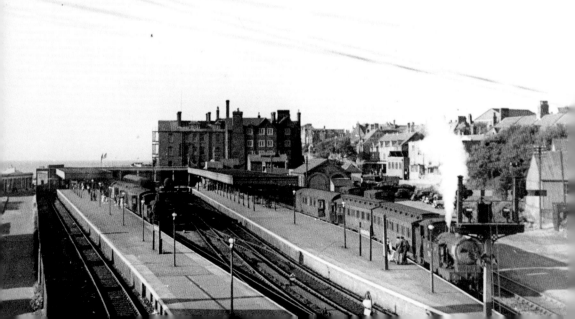

Coasts

So much of the Victorian railway boom in Norfolk had been directly connected to the surge in popularity of north Norfolk as a holiday destination. The east coast of the county became equally popular. A nineteenth-century passion for the outdoors and a newfound freedom of transport, coupled with paid holiday time off work, laid the foundations for the twentieth-century tourism industry.

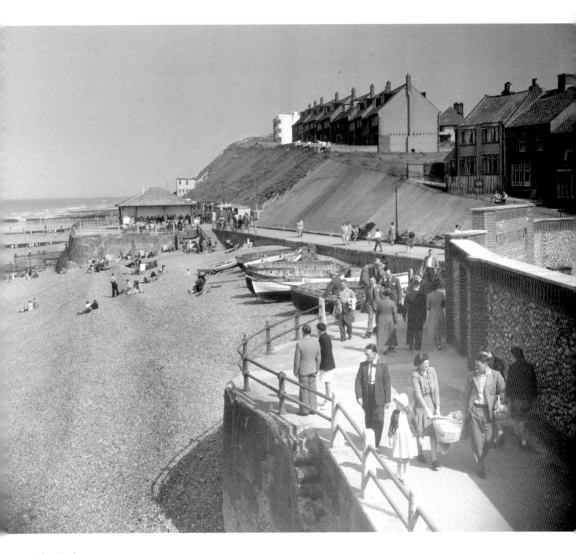

Sheringham
With the war gradually receding in the population's memory, and the threat of invasion, with its restrictions, now long gone, the Norfolk coast became popular all over again. This 1948 photograph shows people on the promenade at Sheringham. (Historic England Archive)

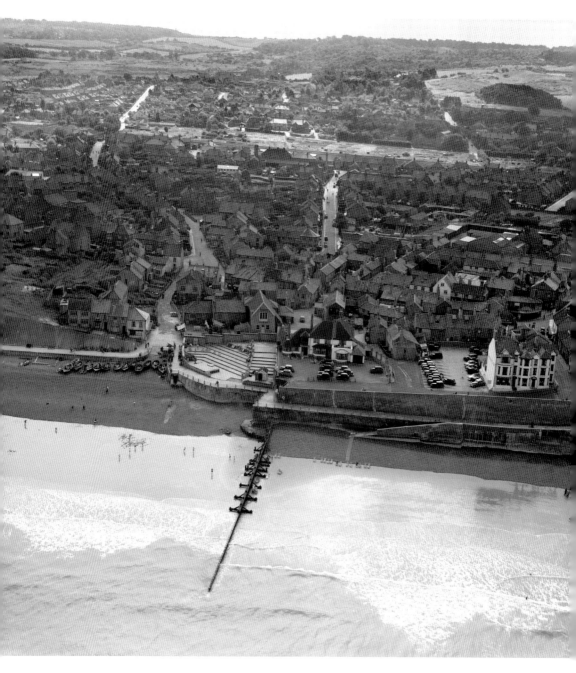

Sheringham
An aerial image from just a few years later, in 1953, gives a spectacular view of Sheringham's
seafront and the town's proximity to the Norfolk countryside. (© Historic England Archive.
Aerofilms Collection)

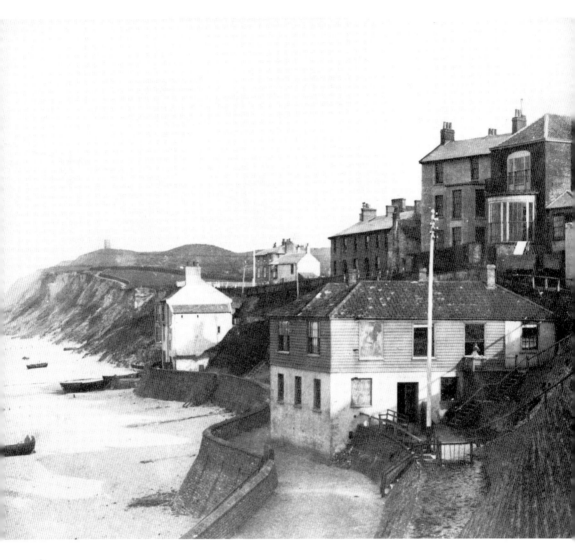

Cromer

This picture was taken, looking south-east, from near the pier in 1867. By then Cromer was already a popular place for holidays, although the atmosphere here is that of a quiet fishing port. Fifteen years later things would change. Around 1883 Clement Scott visited Cromer and began writing about it. Scott was a well-connected London critic and journalist. He coined the name 'Poppyland' for the coastal area around Cromer, Overstrand and Sidestrand. It was Scott's enthusiasm and his articles in the press, together with the railway's arrival, that redefined Cromer and north Norfolk as a holiday destination. (Historic England Archive)

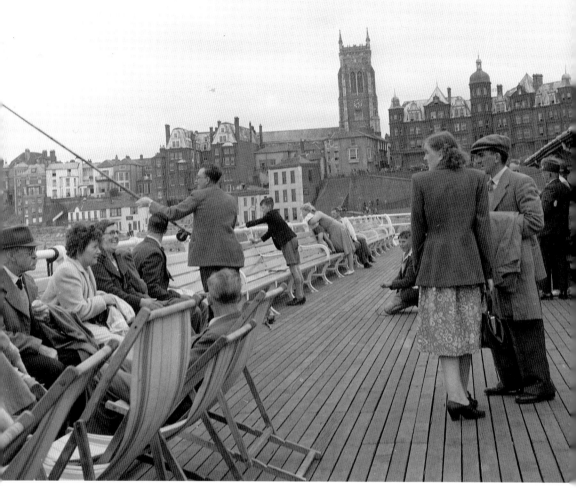

Cromer
This photograph shows Cromer still as a busy and popular place in the 1950s. It's plainly not the sunniest of days, but visitors and anglers are determined to make the most of some time on the pier. (Historic England Archive)

Opposite above: Cromer
It's possible to trace Cromer Pier's history back to 1391. Certainly in 1582 Elizabeth I wrote a letter granting rights for the pier to be used for shipping out wheat and barley. An 1822-built pier was destroyed by a storm in 1846. Its replacement, which had become hugely popular with holidaymakers, was terminally damaged when a boat crashed into it in 1897. The next incarnation was opened in 1902. Refurbished and repaired after a storm in 2013, the pier remains as an essential part of Cromer's charm. This picture of Cromer Pier is from the 1990s. (© Crown copyright. Historic England Archive)

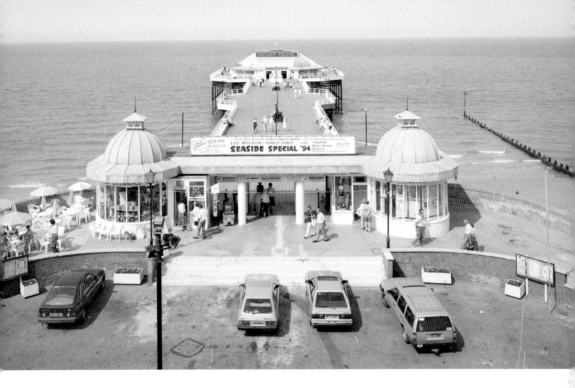

Below: Hunstanton

A hundred years earlier, in 1899, Hunstanton was showing little sign of tourism. Its all-important lighthouse stands proud in this impressive view. The first Hunstanton lighthouse had been built in the thirteenth century. A later wooden construction used burning coals for a light. In 1776 an oil lamp was installed, together with a reflective surface to intensify the beam. It was the world's first parabolic reflector. More innovations were introduced in the next lighthouse, built in 1840. It operated until 1922. (© Historic England Archive)

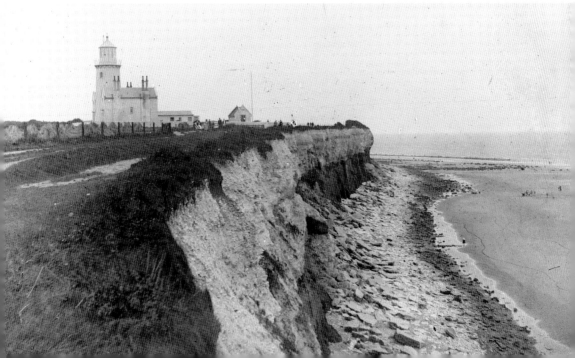

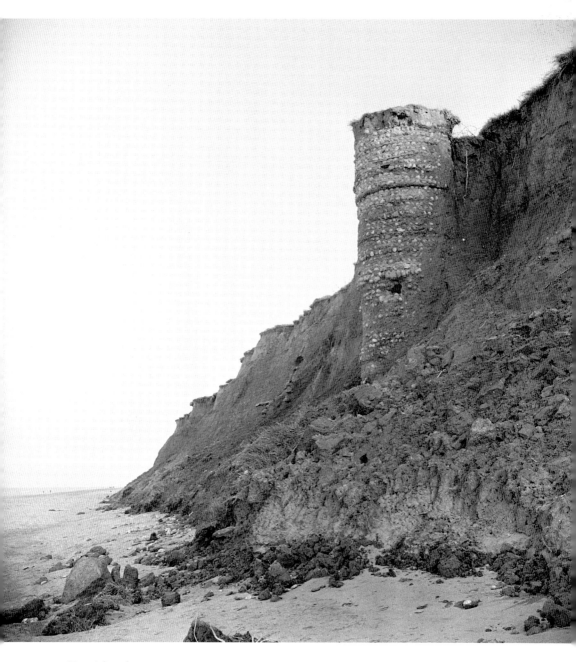

Happisburgh
Happisburgh is also famous for its lighthouse, but the place has long been on the front line of danger from erosion. In fact Happisburgh was once some distance from the sea. Although accelerating now, the erosion of the coastline here has been happening for 5,000 years when it's known that the sea levels rose. This 1947 photograph, at Ostend, Happisburgh, gives a dramatic insight into the erosion. The cliffs have fallen away to such an extent that they have revealed a medieval well shaft that was once inland. (Historic England Archive)

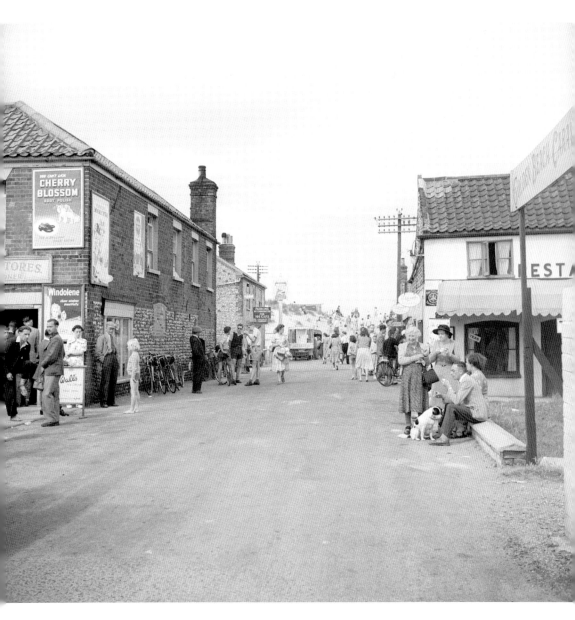

Sea Palling

Another popular spot on the Norfolk coast, this photograph of Sea Palling was taken in July 1951, looking towards the dunes. The holiday atmosphere of the shot is in stark contrast to the dreadful events of January 1953 when the sea broke through along the Norfolk coast, killing seven people in Sea Palling alone. There had been a gale blowing for two days but by the Saturday evening conditions had become critical. The sea level was running at 2 metres higher than normal and when the storm hit the Norfolk coast there was nothing anybody could do. A hundred people died around Norfolk as the torrent swept in. It would be estimated that 3,500 homes had been ruined. It had hit Sea Palling at around 6.00 p.m. By 9.00 p.m. it was battering Great Yarmouth. (Historic England Archive)

Great Yarmouth

Great Yarmouth has an important place in the history of Norfolk and it features in several images in the archive. There are photographs that span over a century and show the town as both a busy working port and a holiday resort. This nineteenth-century image shows the Sailors' Home on Great Yarmouth's Marine Parade. At this point the building was still quite new and functioning as a refuge for shipwrecked sailors. It would become a maritime museum. (Historic England Archive)

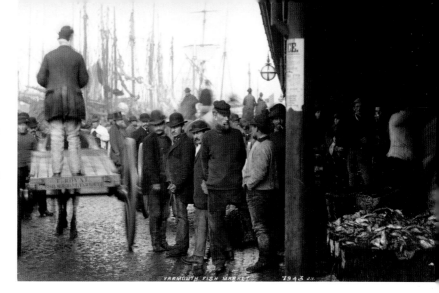

Great Yarmouth
The fish market in Great Yarmouth is rooted in the town's herring industry. It declined rapidly during the twentieth century but in this 1897 image the fish market is still a bustling place. (Historic England Archive)

Great Yarmouth
An aerial view from 1920 shows the size and density of the town. The river and South Quay are the main features here, but what's also visible is the spread of Great Yarmouth away from the seafront. (© Historic England Archive. Aerofilms Collection)

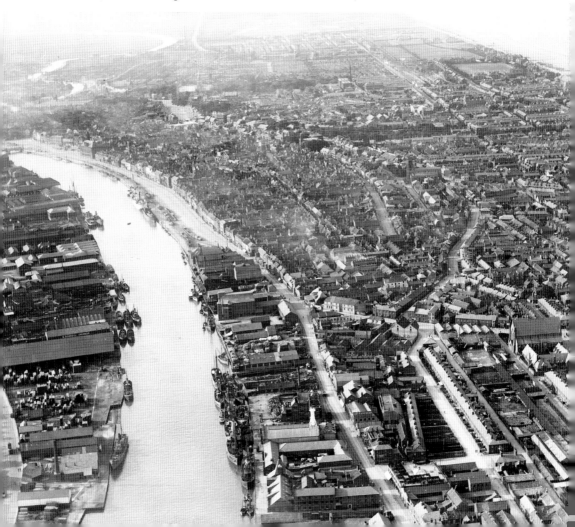

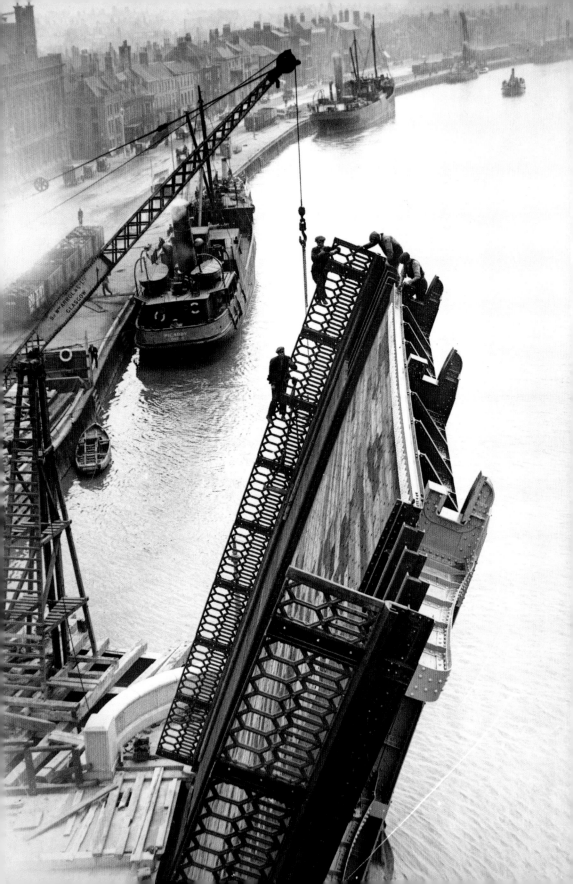

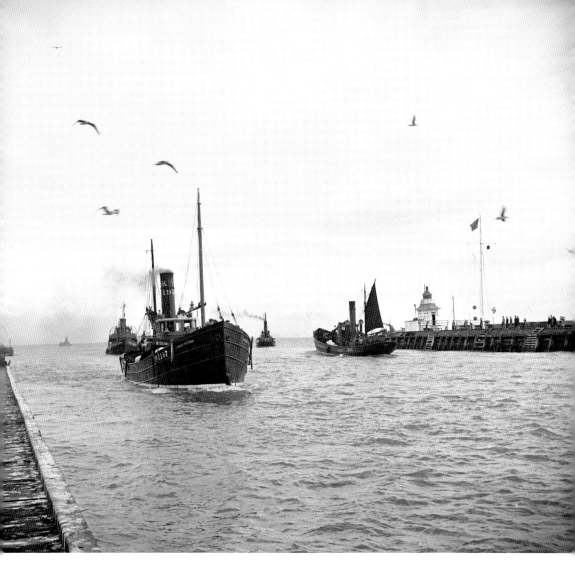

Above and overleaf: Great Yarmouth

These images from 1947 capture the fishing fleet of post-war Great Yarmouth. The herring drifters are coming in at Gorleston and are then moored at the quayside prior to selling their catch. Great Yarmouth had once been the most important herring port in the world. Thousands of Scottish seasonal workers – the 'Scots fisher girls' – would arrive in the town to salt and barrel fish for onward exporting. At the turn of the twentieth century there were a thousand vessels working from here. By the time of these 1940s photographs the decline was already underway. The 1970s saw the last of the herring drifters. (Historic England Archive)

Opposite: Great Yarmouth

Close to South Quay and looking south-east along the river, this dramatic picture from 1928 shows workmen holding on to the lifting section of Haven Bridge. There had been a bridge here for centuries, with some records showing a crossing in the fifth century. A Victorian bridge was opened in 1854. This archive shot shows the twentieth-century Haven Bridge in the final stages of construction before it was opened by HRH the Prince of Wales on 21 October 1930. (Historic England Archive)

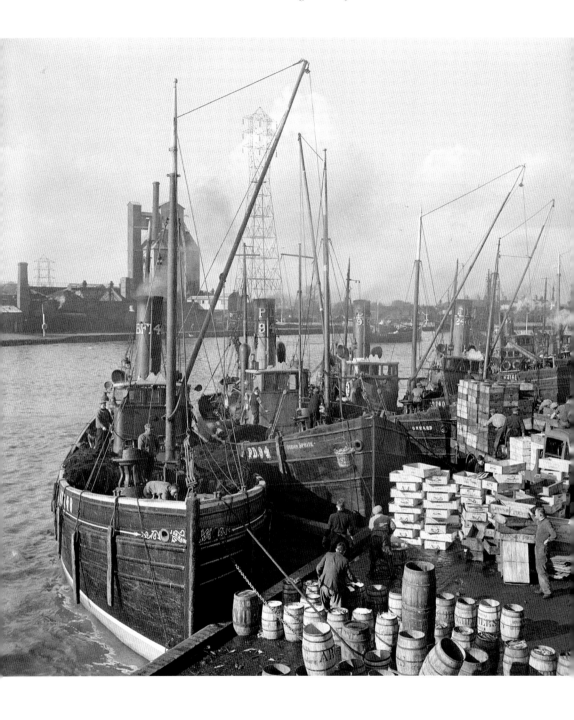

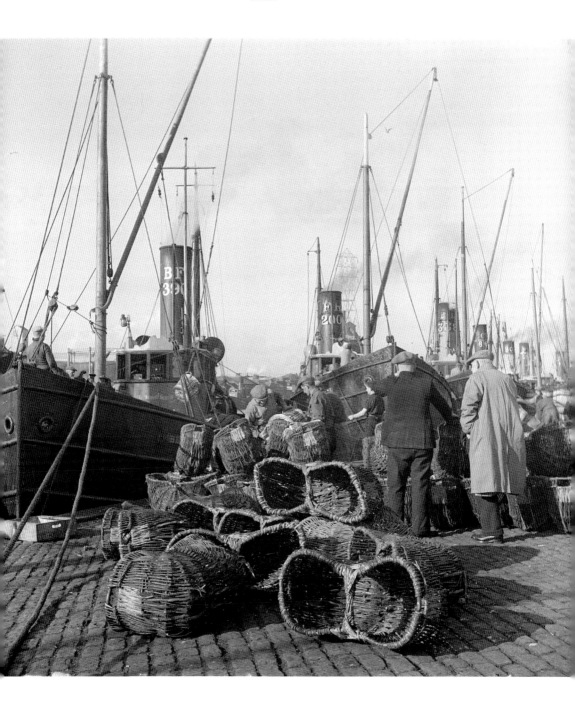

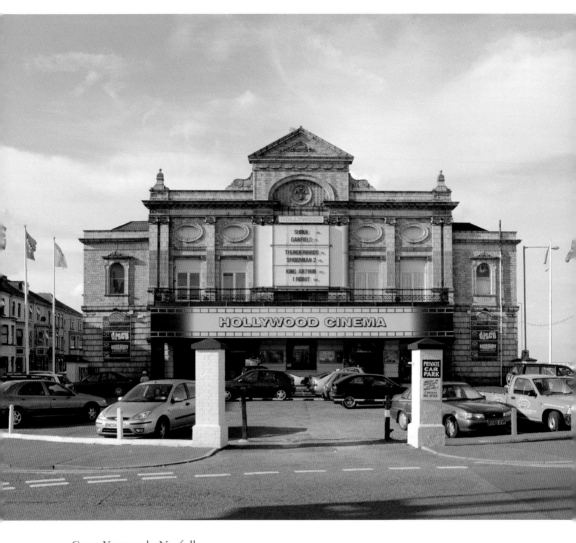

Great Yarmouth, Norfolk
The Hollywood Cinema on Marine Parade in 2004. Originally built in 1876, this was once
the Royal Aquarium. That venture had not proved particularly successful and the building
was converted to a theatre in the 1880s. Its use as a cinema goes back in part to 1904 and has
remained as such, in various forms, ever since. (© Historic England Archive)

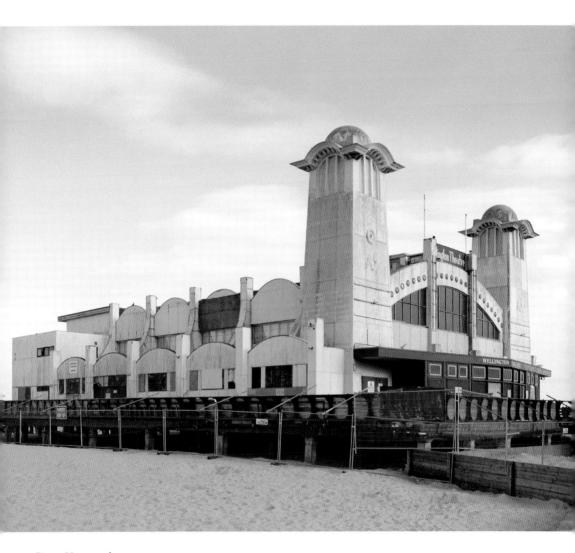

Great Yarmouth
Predating the Royal Aquarium building by a couple of decades, the Wellington Pier was opened in 1853 and named after the legendary duke, who had only recently died. The twentieth century saw the pier go through refurbishments and star-studded shows, as well as part demolition. Pictured here in 2004, the building itself still looks as impressive as ever. (© Historic England Archive)

Grand Houses

When it comes to impressive buildings, Norfolk is blessed with many grand houses. They range from the truly ancient to the Victorian, Edwardian and even later. Prominent among them is Sandringham. Sandringham House is justifiably famous worldwide because it's been the private home of British monarchs since 1862. Elizabeth II inherited Sandringham from her father, George VI, when he died in 1952. In 1957 she made her first televised Christmas message from Sandringham. In 1977, to mark her silver jubilee, she opened Sandringham to the public, even though it is one of her private homes. A series of photographs in the archive, from January 1889, give us a rare insight of the house during the late nineteenth century.

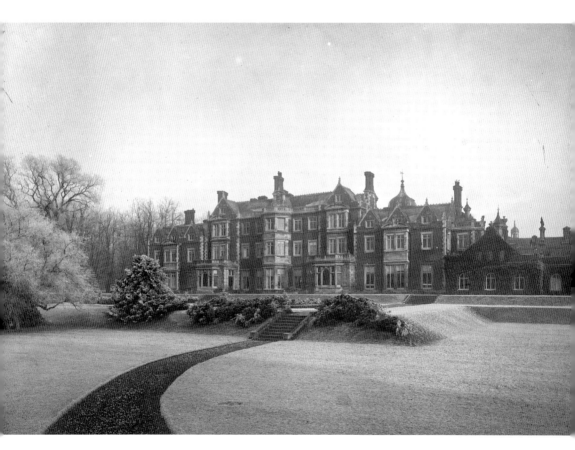

Sandringham House

The royal connection to Sandringham House dates from the 1860s because it was then that the house and nearly 8,000 acres of land were bought for Albert Edward, the Prince of Wales, and his fiancée, Princess Alexandra. From 1870 to 1900 Edward VII, as he would become in 1901, effectively rebuilt the house and developed the estate. This photograph dates from the winter of 1889. (Historic England Archive)

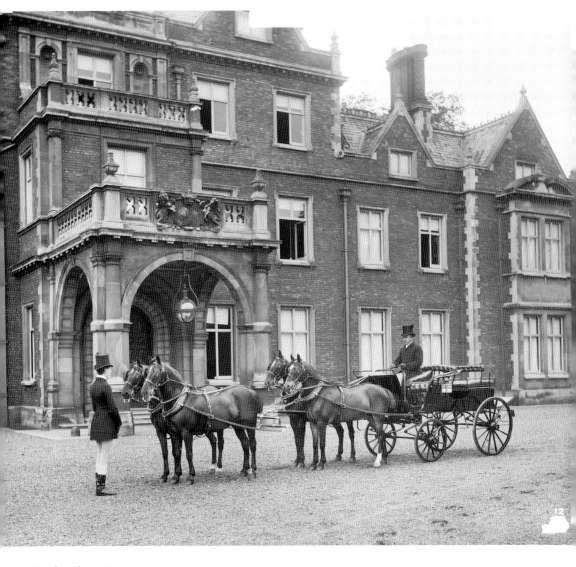

Sandringham House
In the summer of the same year a four-in-hand carriage waits outside the entrance to Sandringham House. Constant arrivals and departures of guests for what became legendary weekend shooting parties were the norm at Sandringham during the late nineteenth and early twentieth centuries. (Historic England Archive)

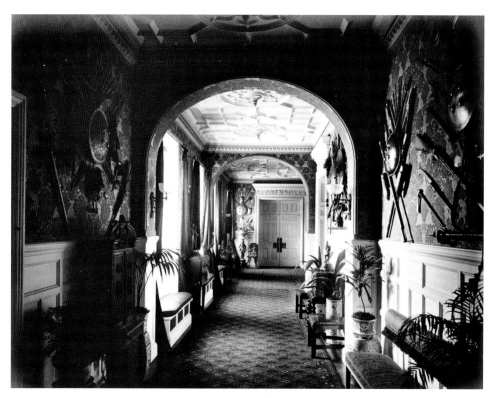

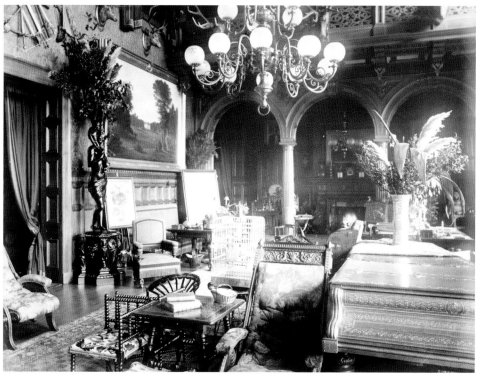

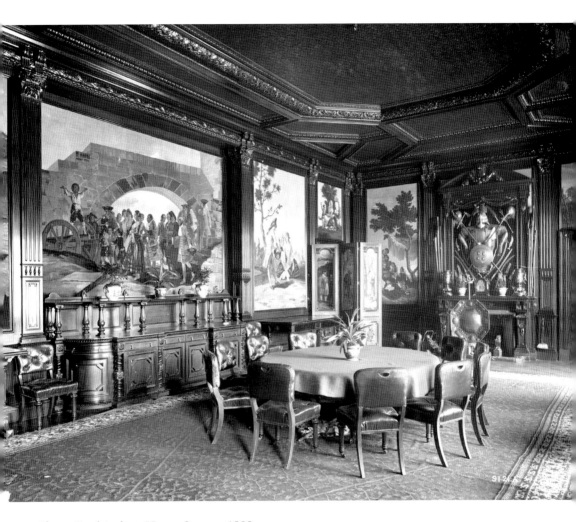

Above: Sandringham House, January 1889
The dining room featured an impressive fireplace and panelled walls. Queen Mary had the panels painted light green. It was not unusual to have the dining table laid for twenty-four guests at a time. (Historic England Archive)

Opposite above: Sandringham House, January 1889
A view along the corridor towards the ballroom. The ballroom had been added in 1884 to avoid the necessity of moving furniture out of the main saloon to allow for dances and balls. Princess Alexandra was reportedly thrilled at the development. In the year of this photograph Queen Victoria visited Sandringham and the ballroom was used to put on a 'theatrical performance' for her by the stars of the day Sir Henry Irving and Ellen Terry. (Historic England Archive)

Opposite below: Sandringham House, January 1889
The salon, or saloon, at Sandringham House in all its Victorian splendour. The largest room in the house, it was the family's main living area. Constantly rearranging the saloon for dances was the catalyst for adding the ballroom. Edward VII had a weighing machine in the saloon. He liked to weigh guests as they arrived and again as they left. He wanted to measure the effects of his hospitality! (Historic England Archive)

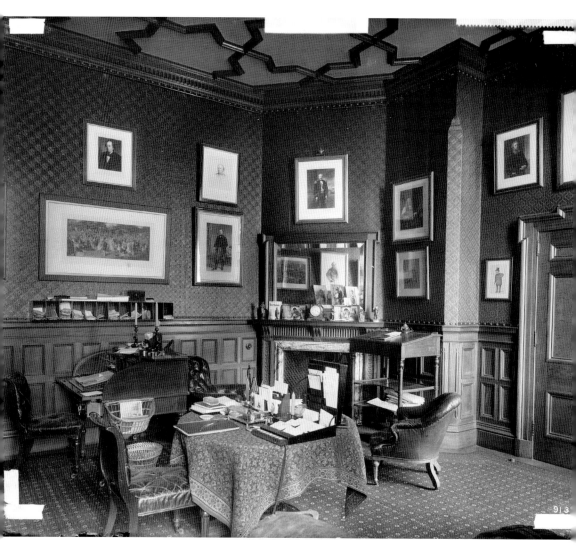

Above: Sandringham House, January 1889
The Prince's Room at Sandringham. (Historic England Archive)

Opposite above: Sandringham House, January 1889
The Princess' Boudoir, displaying a markedly feminine decor when compared to the Prince's Room. (Historic England Archive)

Opposite below: Sandringham House, January 1889
Victorian Sandringham boasted its own bowling alley. (Historic England Archive)

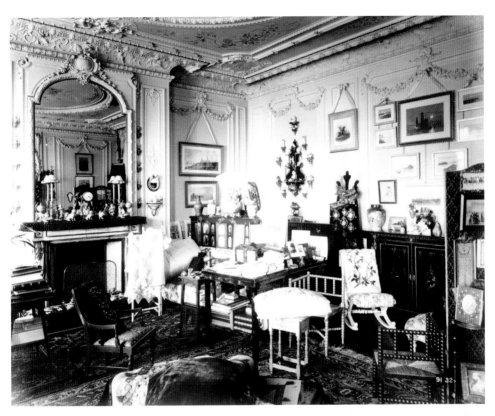

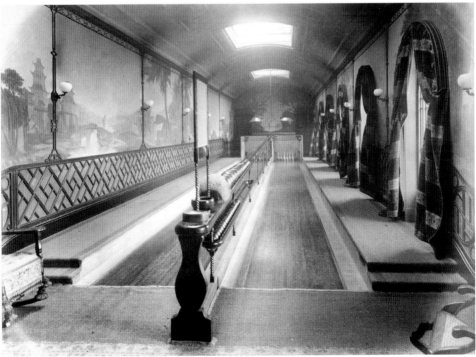

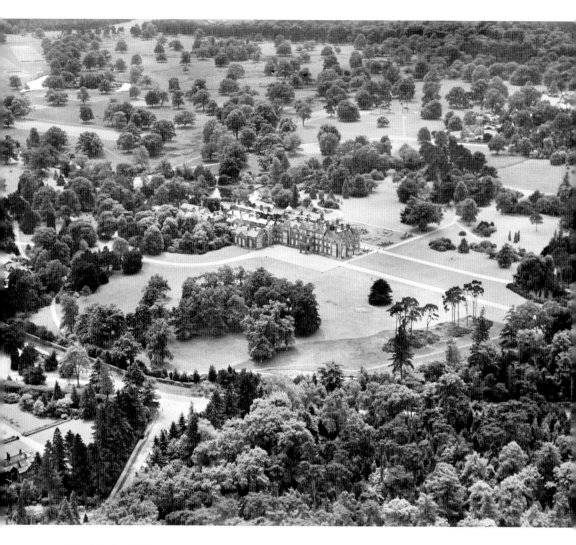

Sandringham House
By 1928, when this aerial view was taken, the Sandringham estate had already grown considerably. Today it covers 20,000 acres. The house and lands had passed to George V when Edward VII died in 1910. George loved the place, calling it 'dear old Sandringham, the place I love better than anywhere else in the world'. (© Historic England Archive. Aerofilms Collection)

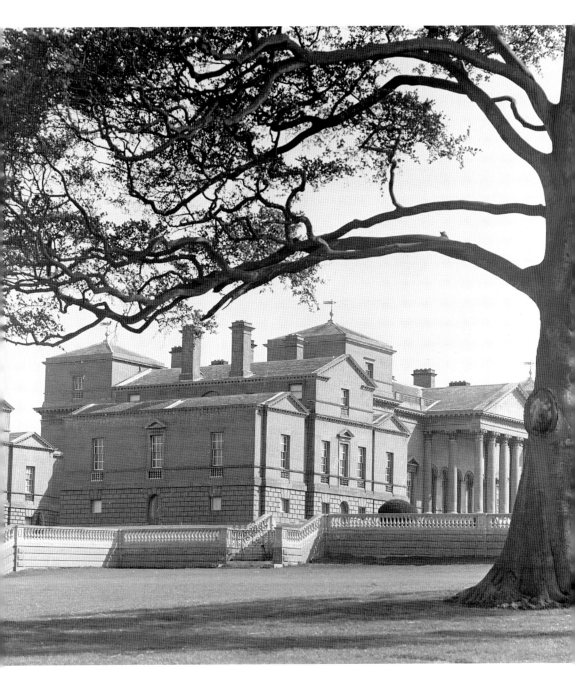

Holkham Hall
A twentieth-century image of an eighteenth-century house. Holkham is acknowledged as one of the finest examples of the Palladian revival style of architecture. It's certainly one of Norfolk's most impressive grand houses. Built for the 1st Earl of Leicester, its severe exterior design complemented the luxurious decoration and furnishings of the interior. (© Historic England Archive)

Holkham Hall
Thomas William Coke, 1st Earl of Leicester, inherited the 30,000 acres of Holkham when his father died. He became MP for Norfolk in 1776, but after losing his seat in the 1784 general election he returned to Norfolk to concentrate on the development and maintenance of Holkham. He is generally credited as being instrumental in instigating the agricultural revolution. (© Historic England Archive)

Acknowledgements

All of the images in this book come from the Historic England Archive, and I am grateful to them for giving Amberley Publishing, and me, permission to use them.

I'd like to thank the team at Amberley. A special thanks to commissioning editor Nick Grant for commissioning the book and for his help and understanding.

As ever, a huge thanks to my wife Sue. Without her patience and support I'd be lost. Thanks Susie!

About the Author

Pete Goodrum is a Norwich man. He has had a successful career in advertising, working on national and international campaigns, and now works as a freelance advertising writer and consultant.

Pete is also a successful author. Among his books, published by Amberley, *Norwich in the 1950s*, *Norwich in the 1960s* and *Norfolk Broads: The Biography* have all topped the local bestseller charts, and all the others have made the top five.

He makes frequent appearances on BBC radio covering topics ranging from advertising, music and local history to social trends. He also writes and presents TV documentaries, and he's a much in demand public speaker.

A regular reader at live poetry sessions, and actively involved in the media, Pete has a real passion for the history of Norfolk and Norwich. He lives in the centre of the city with his wife Sue.

About the Archive

Many of the images in this volume come from the Historic England Archive, which holds over 12 million photographs, drawings, plans and documents covering England's archaeology, architecture, social and local history.

The photographic collections include prints from the earliest days of photography to today's high-resolution digital images. Subjects range from Neolithic flint mines and medieval churches to art deco cinemas and 1980s shopping centres. The collection is a vivid record both of buildings that are still part of everyday life – places of work, leisure and worship – and those lost long ago, surviving only in fragile prints or glass-plate negatives.

Six million aerial photographs offer a unique and fascinating view of the transformation of England's towns, cities, coast and countryside from 1919 onwards. Highlights include the pioneering photography of Aerofilms, and the comprehensive survey of England captured by the RAF after the Second World War.

Plans, drawings and reports provide further context and reconstruction artworks bring archaeological sites and historic buildings to life.

The collections are housed in a purpose-built environmentally controlled store in Swindon, which provides the best conditions to preserve archive items for future generations to enjoy. You can search our catalogue online, see and buy copies of our images, as well as visiting our public search room by appointment.

Find out more about us at HistoricEngland.org.uk/Photos
email: archive@historicengland.org.uk
tel.: 01793 414600

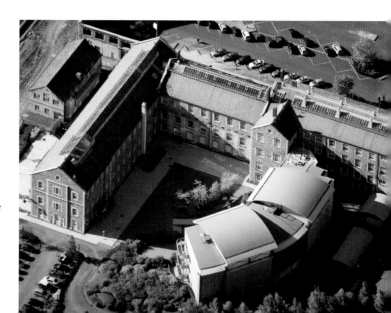

The Historic England offices and archive store in Swindon from the air, 2007.